Film School

Develop the tools you will need to succeed before, during and after your film school education.

Film School: A Practical Guide to an Impractical Decision is a specific, straightforward guide to applying, getting into, and thriving in film school and in the industry in general. Not only does this book appeal to both prospective and current film students, it also features an in-depth discussion of the application process, both from the graduate and undergraduate perspective. You will learn how to choose between different schools and programs, avoid debt, succeed at festivals, and transition out of film school and into the work world. Author Jason Kohl offers:

- Tips on how to develop your voice before attending film school
- A chronological layout that allows you to continually refer to the book throughout your film school process
- Advice on how to gauge the cost of attending film school

Whether you are just starting the application process, or are a recent film school graduate, *Film School* gives important advice and insider knowledge that will help you learn and grow in the film industry. This book is a must-have for anyone who wants to know what it takes to succeed in film school and beyond.

Jason B. Kohl is an Austrian/American filmmaker, author and teacher from Michigan. His short films have played SXSW, Los Angeles, Locarno, BFI London and been finalists for the Student Academy Awards. Jason is currently financing his first feature film, with production planned for 2016. He's a former Fulbright and DAAD Artist Scholar with an MFA in Directing from UCLA Film School. This book is a resource he wished he had in applying to film schools and beginning a career as a young filmmaker.

Film School

A Practical Guide to an Impractical Decision

Jason B. Kohl

Focal Press
Taylor & Francis Group

NEW YORK AND LONDON

First published 2016
by Focal Press
70 Blanchard Road, Suite 402, Burlington, MA 01803

and by Focal Press
2 Park Square, Milton Park, Abingdon, Oxon OX14 4RN

Focal Press is an imprint of the Taylor & Francis Group, an informa business

Library of Congress Cataloging-in-Publication Data
Kohl, Jason.
 Film school : a practical guide to an impractical decision / by Jason Kohl.
 pages cm
 1. Motion pictures—Study and teaching (Graduate)—United States I. Title.
 PN1993.8.U5K64 2015
 791.43071'173—dc23
 2014044986

ISBN: 978-1-138-80424-1 (hbk)
ISBN: 978-1-138-80425-8 (pbk)
ISBN: 978-1-315-75314-0 (ebk)

Typeset in Adobe Garamond Pro
By Apex CoVantage, LLC

Printed and bound in the United States of America by
Edwards Brothers Malloy on sustainably sourced paper

Dedication

To my parents, to whom my gratitude defies words.

Bound to Create

You are a creator.

Whatever your form of expression — photography, filmmaking, animation, games, audio, media communication, web design, or theatre — you simply want to create without limitation. Bound by nothing except your own creativity and determination.

Focal Press can help.

For over 75 years Focal has published books that support your creative goals. Our founder, Andor Kraszna-Krausz, established Focal in 1938 so you could have access to leading-edge expert knowledge, techniques, and tools that allow you to create without constraint. We strive to create exceptional, engaging, and practical content that helps you master your passion.

Focal Press and you.

Bound to create.

We'd love to hear how we've helped
you create. Share your experience:
www.focalpress.com/boundtocreate

Focal Press
Taylor & Francis Group

Contents

Acknowledgments

Thank you to my partner Nora, my first line of defense in life.

Thank you to my wonderful UCLA professors, Nancy Richardson, Becky Smith, and Howard Suber (my Socrates), for their support of this book.

Thank you to Julia Fontana for taking the time to explain to me the international issues that students face.

Thank you to Nick Palmer for his excellent advice on the industry.

Thank you to Jan Marie and Bob Evans for allowing me the use of their lovely home while writing this book.

Thank you to my classmates at UCLA, who taught me just as much as the films I made there.

Foreword

THE INHERENT PROBLEM OF TALKING ABOUT WHETHER ONE SHOULD GO TO FILM SCHOOL IS THAT IT CARRIES WITH IT THE ENORMOUS COMPLEXITY OF COST. HULK COULD SPEND HOURS TALKING ABOUT THE DREADFUL ECONOMICS OF HIGHER EDUCATION, WHETHER IT BE THE DRASTIC IMPACT ON THE MIDDLE CLASS, THE UNADVERTISED HIGH COSTS OF ADDITIONAL EDUCATIONAL MATERIALS OR EVEN THE HAUNTING ALBATROSS OF STUDENT LOANS—WHICH JUST MEANS THAT ANY AND ALL FILM SCHOOL QUESTIONS CAN'T HELP BUT BE TEMPERED WITH THE INITIAL QUESTION OF: "WHAT IS YOUR ECONOMIC SITUATION LIKE? CAN YOU REALLY AFFORD IT?"

IF YOU REALLY, TRULY CAN'T AFFORD IT, THEN YES, PERHAPS IT'S WORTH IT TO TAKE A CHANCE ON DIVING RIGHT INTO THE WORKING WORLD INSTEAD OF ATTAINING A MOUNTAIN OF INSURMOUNTABLE DEBT. AND BECAUSE OF THIS, THAT MEANS THAT NO MATTER WHAT "THE ANSWER" OF WHETHER OR NOT YOU SHOULD GO TO FILM SCHOOL, THE DECISION IS GOING TO REQUIRE A SLIDING SCALE DEPENDING ON EVERY SINGLE PERSON'S UNIQUE SITUATION.

HOWEVER, THE CENTRAL QUESTION CAN BE AUGMENTED BEAUTIFULLY. WE CAN REMOVE THE VARIABLE OF COST AND INSTEAD ASK ONE SIMPLE, POINTED QUESTION IN ITS PLACE:

DOES FORMAL FILM EDUCATION HAVE GREAT VALUE IN AND OF ITSELF?

THE ANSWER IS ABSOFREAKINLUTELY.

WHILE MANY ARGUE THAT FILM SCHOOL IS A WASTE OF TIME, HULK CAN DISMISS THAT WITH A SIMPLE "OF COURSE NOT." BUT TO PROVE SO, HULK IS ACTUALLY GOING TO GO THE OPPOSITE DIRECTION BY EXAMINING THE KIDS WHO WILL ENTER FILM SCHOOL AND BELIEVE IT WILL FORGE

THEM IN THE FIRE OF COMPETITION, ALLOWING THEM TO EMERGE AS A ROCK STAR AMONG THEIR PEERS AND BE GIVEN A YELLOW BRICK ROAD RIGHT TO HOLLYWOOD.

IN FILM SCHOOL, THEY WILL HOPEFULLY LEARN THAT SUCH EXPECTATIONS ARE NOT ONLY NONSENSE BUT COUNTERPRODUCTIVE TO THE SINGLE BEST PART ABOUT THEIR EDUCATION . . .

FILM SCHOOL IS AN INCREDIBLE PLACE TO MAKE MISTAKES.

REALLY. SO MUCH OF YOUR PERSONAL DEVELOPMENT WILL RELY ON NECESSARY FAILURE AND FURTHER RE-EVALUATION. IT'S THE TRIAL AND ERROR METHOD WRIT LARGE. BECAUSE FILMMAKING IS SO ROOTED IN THE NOTION OF TAKING WHATEVER IDEA IS IN YOUR HEAD, WHETHER IT IS AN IMAGE, A STORY BEAT OR A LIGHTING TEXTURE, AND BEING ABLE TO TRANSLATE THAT ABSTRACT NOTION INTO SOMETHING REAL. AND DOING SO IS NOT A STRICTLY INTUITIVE PROCESS. IT TAKES LOTS OF TIME AND CONSTANT FAILURE. IT'S A KIND OF FAILURE THAT NEVER, EVER STOPS TO BE HONEST. WHEN YOU BECOME A PROFES-SIONAL, YOU REALIZE IT IS PART OF THE GRAND PROCESS OF FILMMAKING: *THE ART OF REFINEMENT*. BUT TO SEE SUCH FAILURE AND CORRECT, YOU HAVE TO HAVE BEEN THERE MANY TIMES. AS SUCH, THERE IS A REASON THE PIXAR MODEL IS BUILT ON A "HURRY UP AND FAIL" MANTRA. IT'S WHAT ALLOWS THEM TO TRULY PUT THEIR GENIUS TO WORK. AND SO IF YOU ARE FORGING YOUR UNDER-STANDING IN FILM SCHOOL, YOUR BIGGEST ADVANTAGE IS THAT YOU ARE GIVEN AN ALMOST UNPRECEDENTED SITUATION TO "FAIL" WITH NO LARGER PROFESSIONAL CONSEQUENCES. IN FACT, YOU ARE ONLY PRESENTED WITH MORE OPPORTUNITIES TO GROW.

THE OTHER REASON THE FILM SCHOOL COMPETITION/ ROCK STAR IMAGE IS SO INANE IS BECAUSE FILM SCHOOL IS AN INCREDIBLE OPPORTUNITY FOR YOU TO START BUILD-ING A COMMUNITY. BECAUSE FILMMAKING IS PERHAPS THE MOST COLLABORATIVE ART FORM ON THE PLANET AND YOU WILL ABSOLUTELY NEED TRUSTED COLLABORATORS AND FRIENDS. PEOPLE THAT YOU WOULD TRUST WITH THE

ENTIRE PRODUCTION IF NEED BE. BECAUSE HULK ASSURES YOU SUCH TRUST WILL BE NECESSARY. SO THE EARLIER YOU CAN GROUND YOURSELF IN HEALTHY GROUP DYNAMICS, AND THE EARLIER YOU CAN FIND PEOPLE WHO WILL SUPPORT AND DEPEND ON YOU IN TURN, THE MORE SUCCESS YOU WILL BUILD FOR THE FUTURE, ESPECIALLY IF YOU ENTER THE PROFESSIONAL ARENA TOGETHER LATER ON. BECAUSE YOU WILL REALIZE THAT THERE IS ABSOLUTELY ZERO NEED FOR COMPETITION AND JEALOUSY, AS THE OLD CLICHÉ OF "A RISING TIDE LIFTS ALL BOATS" HOLDS MORE TRUE FOR THIS INDUSTRY THAN PERHAPS ANY OTHER (THERE ARE A LOT OF JOBS ON A BIG FILM SET, FOLKS).

BUT MORE THAN THAT, HULK HAS TO ADMIT THAT HULK IS AN OLD SOFTY FOR THE PLAIN AND SIMPLE NOTION THAT EDUCATION ITSELF, THE PURSUIT OF KNOWLEDGE AND ALL THAT COMES FROM IT, IS PERHAPS THE MOST SACRED ACT WE HAVE AS A SOCIETY. IT IS THE CORNERSTONE OF OUR MODERN DEVELOPMENT, THE DRIVING ENGINE OF ECONOMY, THE LIFEBLOOD OF A PRODUCTIVE SOCIETY. BUT MORE THAN THAT, EDUCATION HAS BEEN SO PARAMOUNT TO JUST ABOUT EVERY LITTLE BIT OF SUCCESS IN HULK'S CAREER. SERIOUSLY. AND BECAUSE YOU HOLD THIS WONDERFUL BOOK IN YOUR HANDS, HULK WAGERS THAT YOU VALUE EDUCATION, WHETHER FORMAL OR INDEPENDENT, JUST AS MUCH AS HULK DOES. SO PLEASE LET HULK TRY AND MAKE THE CASE FOR SUCH MERITS.

FILM SCHOOL CAN HELP MOLD YOU INTO A BETTER, MORE OPEN PERSON. IT WILL FORCE YOU TO ENCOUNTER THINGS THAT ARE BEYOND YOUR UNDERSTANDING. IT WILL EXPOSE YOU TO CINEMA THAT IS OUTSIDE THAT WHICH YOU CURRENTLY LIKE. IT MAKES YOU GROW, LEARN AND CHALLENGE YOURSELF. AND IT ULTIMATELY DEMANDS THAT YOU WORK HARD, THAT YOU ERASE ANY RESIDUE OF ENNUI AND APPLY YOURSELF.

HARD WORK . . . IT'S JUST SO PARAMOUNT TO EVERYTHING.

BECAUSE FILM SCHOOL . . . NO FILM SCHOOL . . . THESE ARE SIMPLY TWO PATHS. BOTH ARE VALID. BOTH HAVE OBSTACLES. BOTH HAVE ENORMOUS BENEFITS. AND BOTH

STRETCH OUTWARD TO THE SAME INEFFABLE GOAL OF ACCOMPLISHING YOUR DREAM. BUT IF YOU MANAGE TO ACCOMPLISH EXACTLY WHAT BOTH PATHS ILLUSTRATE, YOU WILL COME TO AN ALL-IMPORTANT DISCOVERY. YOU WILL REALIZE *A DREAM IS NOT SOMETHING THAT IS ACCOM-PLISHED* . . .

A DREAM IS THE ATTAINING OF A CONSTANT STATE OF CONTENTMENT IN DOING HARD WORK THAT YOU ENJOY.

HARD WORK THAT FULFILLS YOU. THAT MAKES YOU FEEL ALIVE AND VITAL. THERE IS NO TOP OF THE MOUNTAIN. THERE COULDN'T BE, FOR THIS INDUSTRY PROVIDES SO FEW MOMENTS OF ACTUAL TRIUMPH. THERE IS SIM-PLY YOUR HAPPINESS WITH THE PROCESS. THERE IS NO SATISFACTIONS IN THE REWARDS. THEY DO NOT REALLY EXIST. YOUR SATISFACTION RESTS IN A JOB WELL DONE. IT DEPENDS ON YOUR BELIEF IN THE WORK ITSELF. THE BELIEF THAT WHAT YOU DO IN THIS INDUSTRY MATTERS. IT IS THE BELIEF THAT YOU ARE *THE "ETERNAL STUDENT" OF YOUR OWN PROFESSION.*

AND THE SOONER YOU OWN THAT REALIZATION, THE SOONER REAL HAPPINESS CREEPS INTO YOUR SOUL

WITH THAT . . . BE SMART. BE DEDICATED. BE KIND. BE GOOD.

REPEAT.

AND KNOW THAT HULK WISHES YOU WAY MORE THAN LUCK,

FILM CRIT HULK

Introduction: Middle-Aged Olympians

They who lack talent expect things to happen without effort.
Eric Hoffer, *Reflections on the Human Condition*

In 2012 the United States sent 530 athletes to the summer Olympics.

Their average age: 26.

In 2012 the Academy Awards nominated 49 individual filmmakers in the categories of screenwriting, directing, producing, editing, cinematography and documentary.

Their average age: 50. Almost twice that of the Olympians.

Some more sobering statistics:

1. UCLA, like NYU, USC and most top film schools, accepts less than 5 percent of applicants.
2. Of those accepted, around 1 percent make a successful feature film.

All this is to say that a career making feature films is incredibly difficult to achieve. Very few people, including the majority of top film school graduates, ever do it.

So why buy this crazy book? Why not spend the money on an LSAT prep course and a nice bottle of bourbon?

Because studies show that people who think achieving a goal will be difficult plan better, work harder, and persist longer than people who think it'll be easy. In other words, they actually give themselves a shot at succeeding.

A big part of individual success comes from an ability to manage your expectations. As I continue on my own path as a filmmaker, I realize how much of my frustration stems from my own naïve expectations of how things are supposed to work, usually in my favor. Thus one of my major goals in writing this is to help you conceptualize what film school is, and what getting in actually means.

I hope this book will be a roadmap you can turn to when you get lost, confused or frustrated; believe me, it's all part of the process.

I don't discuss current curriculum or equipment because that information constantly changes. If you're serious about filmmaking, you'll have to do that research on your own anyway.

I made my first narrative short film in 2006. It was shot on a shoestring budget with a two-person crew. Seven years later, my UCLA MFA Thesis Film premiered at the 2013 South by Southwest (SXSW) Film Festival and was a finalist for the Student Academy Awards. Inside this book is everything I learned in

between. My experience is as an emerging writer/director, but this book will benefit people from other disciplines (specifically producing, cinematography, and editing) as well; ultimately we're all in the same boat.

In your hands is the book I wish I'd had throughout my early career as a young filmmaker. I hope it helps you on the long journey ahead.

<div align="right">Jason B. Kohl</div>

Who Needs Film School?

It isn't normal to know what we want. It is a rare and difficult psychological achievement.

Abraham Maslow, *Motivation and Personality*

Ten Reasons to Go to Film School

This book is an extended inquiry into film school, its value, and how to benefit most from your time there. This question has become more acute in our current era, when many film students graduate with significant student loans. So why go to film school? What follows are ten of the strongest arguments to be made for a solid film school education. These are all excellent reasons to exchange two to five years of your life for a significant sum of money.

1. TIME

As filmmakers, we admire legends like Tarkovsky, Kubrick, Bergman or Spielberg for their mastery of the film form. They wow us with their unbelievable insights into the medium and demonstrate the highest form of mastery.

How these people became masters is relatively clear. Aside from their unique personal makeup, they dedicated endless amounts of time to studying and practicing their craft. Depending on who you ask, researchers currently contend that it takes anywhere from 10,000 to 20,000 hours of practice to achieve mastery in a field. Whether those numbers are perfectly accurate is moot; the takeaway is that filmmaking, like painting, athletics, playing the piano or being a rocket scientist, takes a massive amount of time and dedication to master.

In exchange for tuition, film school will give you structured time to practice your craft in a safe, constructive environment. This is perhaps the greatest gift a school can offer.

2. STRUCTURE

Yes, you can omit film school and still become a successful filmmaker. By my estimate, roughly half of working filmmakers do. These filmmakers, including Robert Rodriguez and Werner Herzog, as well as legendary screenwriters like Robert Towne, Bill Goldman and Paddy Chayefsky, essentially created their own apprenticeships to replace a film school education. This is definitely an option, and for many people it's the only option.

That being said, film school is not a passive learning experience, where brilliant professors funnel the secrets of success into your eager ears. A film school education is a constant back and forth between the school's teaching and your own personal learning and development. A film school cannot specialize in sci-fi movies or indie dramas; you have to do that yourself. A

successful film school education thus consists of two parallel learning tracks: the film school curriculum, as well as your own personal development.

When you rebel against film school it's therefore often a sign that film school is working; it's an indication that you're defining your own values and your own unique view of cinema. To do so while continually making creative work, then evaluating that work against your original intentions, all while watching your classmates do the same, is a powerful experience not to be underestimated. This specific experience is also totally unique to film school; it cannot be recreated outside of it.

3. THE FREEDOM (TO FAIL)

There is tremendous freedom within most film schools: you generally write your own scripts or work with a writer, cast your own projects, and (hopefully) see those projects through to completion. Outside of film school you may never have the opportunity to work with so many different collaborators, or to safely make the many mistakes that are part of the process. Failure, confusion and strife cost you more in the real world, if only because they don't have the candy shell of education around them. Though painful, failure is always the best teacher. Film school is a place where you'll be able not only to learn from failure, but also to integrate that knowledge into your next project.

4. THE OPPORTUNITY TO RELOCATE TO A FILMMAKING CENTER

If you do not live in New York or Los Angeles, film school can be your impetus and financing (against debt) to do so. Industries have centers for a reason: the concentration of talent and resources allow filmmaking to be done at the highest level. Filmmaking is an intensely collaborative art form, and most of the great filmmakers live, for obvious reasons, in the industry centers, where jobs and contacts flourish.

5. COMMITMENT/AFFIRMATION

Deciding to become a filmmaker is the financial equivalent of deciding to light your parents' house on fire, provided their house is expensive enough. Very few people who really care about you will let you make the decision lightly. Every family has a crazy artist uncle who drowned in a river in Prague, circa 1923, and your loved ones don't want you to face a similar fate. If your family is all in the arts, maybe you will get a pass here. If they are successful filmmakers, you can probably put down this book right now.

For the rest of us, a prestigious film school can quell the overriding terror that our life choices will inevitably inflict, all while lending our decision an air of legitimacy. Being surrounded by people who share your passion can be a crucial validation for choosing a way of life, and a powerful support network for the difficult journey ahead.

The sheer commitment of going to film school can also free you from your insecurities for a time, though rest assured they will return. While attending film school, your urge to become a filmmaker will be validated and nourished in a way that the outside world simply cannot provide. Throughout your time in film school, you will learn to see yourself as a filmmaker. When you graduate, hopefully that identity will be strong enough to weather the inevitable blows to come.

6. GUIDANCE

Film school professors earn their living by helping you realize your vision. They have spent years watching students succeed and fail in their own courses, and have refined their methods of instruction based on that experience.

The filmmaking process involves many rounds of feedback, on screenplays, on cuts of films, on casting choices, all of which your professors will guide you through. The feedback process is an essential part of learning, and it is the backbone of film school.

Equally remarkable is your ability to go through this process in the company of peers, who will make both similar and different mistakes, all of which you will learn from. There's no other experience quite like film school; it's the magic of a practical education.

7. A PROFESSIONAL NETWORK

Your peers in film school will form an automatic network of intelligent, film-hungry, hardworking collaborators. Again, it is difficult to construct this group of people from scratch; your peers at a top film school will be hand-picked by the faculty for your perceived similarities and differences, as well as your potential to learn and collaborate together.

Even if you don't get along with your peers, the people you meet through screenings, internships, events and shoots will become a part of your trusted support group. In film school, for a few years you will carry the brand of "someone who could make it," which you will trade on in exchange for the

opportunity to learn and grow. You will also have the time to do things like unpaid internships, which offer peeks behind the gates of power, as well as the opportunity to gain valuable contacts. Whether you take advantage of these opportunities are up to you, but they will certainly be there, and, at least in Los Angeles, are often only available to those who can gain school credit. Yes, you can enroll at a community college so you can work for free, but where are you going to hear about the best opportunities? From your network.

It's important to understand that filmmaking opportunities and knowledge are dispersed through an endless private network of people. I cannot tell you how many times I have emailed somebody to ask about a particular piece of equipment, or talent program, or festival, or potential collaborator. The people you meet in film school will ideally read your screenplays, watch rough cuts of your films, relish your triumphs and endure your defeats. There is no force more powerful than a group of people with a shared goal. Again, these people can and will be cobbled together over the years, but film school is often a massive head start.

8. INSURANCE/EQUIPMENT

Today almost anyone has access to a high-quality, high-definition camera. This does not mean that film schools have nothing to offer in this department. Most major schools have equipment packages (and the classmates to crew them) far in excess of what you would be able to come up with on your own. Film school will also teach you that the people behind the camera are far more important than the camera itself, but a good camera never hurts either.

No, this will not offset the debt that you will accrue through film school. It will, however, not only offer you the equipment you need to make professional quality films, but teach you how to properly use that equipment, as well as how to collaborate with the people who operate it.

9. TEACHING CREDENTIALS

The hard truth in life is that most people need to earn a living. An MFA from a prestigious film school is a permanent brand that you can then use to teach others. Many people frown upon teaching, citing the old "those who can't do teach," but this is mere hubris. Some of the greatest filmmakers in history, including Martin Scorsese, taught for several years after they got out of film school.

Not only can teaching earn you a living (and help pay off your debt), it will hopefully allow you to articulate your own philosophy of filmmaking. It will also allow you to repeat the learning process from the other side of the table.

10. PRACTICE

Tens of thousands of hours. To achieve mastery in the flute, architecture, athletics, coding, neuropsychology, you name it. Even famous composers like Mozart and Renaissance painters like Leonardo da Vinci spent decades refining their craft. And guess what? Mozart had many, many piano teachers. The bad news is that geniuses do exist; the good news is that they get there through very hard work.

Film school is the essential place to write, shoot, edit, weep, repeat. This is what you are paying for, and there is no better way to learn. Think of it like learning the scales on a piano: Mozart famously practiced until his fingers were crooked. The only way to greatness is to get your fingers on the keys.

Ryan Koo: Ten Reasons Not to Go to Film School

As the founder of the filmmaking website No Film School, I should first state that I actually agree with all of Jason's "Ten Reasons to Go to Film School." My website is not named No Film School because we are against the concept of film school; it is named No Film School because not everyone can go to film school. If you're holding Jason's book in your hands, then you likely possess the financial and geographic wherewithal to at least think about going to film school, and compared to most of the global population, that puts you in rarefied air! So congratulations on being in a situation where you can even consider throwing gobs of your (or your parents') money at an institute of higher learning! Half the battle is already won.

Seriously, though, there is nothing wrong with film school. For many it will be a career-boosting, connection-making, work ethic-encouraging choice. Indeed, sometimes I wonder where I would be right now if I had gone to film school myself. It's been thirteen years since I won my first filmmaking award, and I'm only now on the cusp of getting my first feature made . . . finally. Had I gone to film school, would that have accelerated my career as a writer/director? You never know—and that's what makes the decision so hard.

Before I launch into a list of reasons not to go to film school, I should note that the cost of film school varies drastically from school to school. If the economics of a well-known, faraway film school don't work out for you, there may be a public school closer to home that offers film studies for in-state tuition at a fraction of the cost. These schools can be wonderful options if you want the structure and guidance of a proper film program. Also, if your family is on board with the idea of you becoming a filmmaker, and they can also afford to cut a check without you bearing the burden of student loans, then the calculation is also different (please refer to #10 below, however). Finally, I want to note that majoring in film as an undergrad generally works out to be the same cost as majoring in anything else. My reasons not to go to film school focus on expensive, specialized graduate programs that tack on additional student loans. By no means would I argue against taking some film classes as an undergrad—indeed, once you've taken a few film classes, you may find that you're already halfway to a major, and sticking to that path will actually allow you to take more classes in a wider variety of subjects, compared to switching to a major where you haven't already built up as many credits. In any given field, a liberal arts major is not the same thing as a graduate degree, and when it comes to film it's the latter I'm going to argue against.

I do want to make it clear that to argue against going to film school is not to argue against the benefits of education and hard work. As Jason notes, "Mozart famously practiced until his fingers were crooked. The only way to

get to greatness is to get your fingers on the keys." I could not agree with this statement more. But nowadays you don't need to go to film school to get your fingers on the keys—or cameras. The decision to go to film school in the 21st century has changed entirely in a digital, connected era, and it's these changes that I'm going to focus on with my response to Jason's ten reasons. Here are ten reasons *not* to go to film school.

1. IT HAS NEVER BEEN MORE EXPENSIVE TO GO TO FILM SCHOOL, AND IT HAS NEVER BEEN CHEAPER TO MAKE A MOVIE

The Internet has disrupted a laundry list of previously irreproachable institutions, and specialized schools—especially film schools—are prime examples. We are living in an age when digital tools have drastically lowered the cost of shooting, editing and distributing movies, and they have democratized the ability to make a movie. We are also living in an age when, in my lifetime, the cost of higher education has outpaced the cost of inflation by a factor of five. Thus, and it bears repeating, it has never been more expensive to go to film school, and it has never been cheaper to make a movie. Financially, film school makes less sense than ever.

2. MANY OF YOUR FAVORITE FILMMAKERS DIDN'T GO TO FILM SCHOOL

Some of today's top directors who didn't graduate from film school: Steven Soderbergh, Robert Rodriguez, Quentin Tarantino, Richard Linklater, Paul Thomas Anderson and Spike Jonze, to name a few (a couple of those guys—and I'm sorry these offhand examples are all male—dropped out of film school, in fact). Of course, you also can find plenty of famous directors who went to film school. But when pointing out famous film school alumni like George Lucas, Martin Scorsese or Francis Ford Coppola, keep in mind that many of them enrolled in a very different era. The next two reasons highlight two of the major differences between film school back when movies were actually shot on film and film school today.

3. YOU DON'T NEED ACCESS TO EXPENSIVE CELLULOID EQUIPMENT

One of the primary reasons to go to film school back when Scorsese et al. attended was to gain access to the tools: 35mm or Super 16 equipment was too expensive to own, and celluloid film was much more costly to shoot on and edit. Back in their day, the only way to get a high-quality image that

didn't immediately scream "amateur" was to shoot on film. Video cameras yielded interlaced, smeary footage that seldom worked for narratives. Nowadays, however, most films are shot digitally, and the 24-frame-per-second, shallow-depth-of-field aesthetic that is the generally accepted motion picture standard is attainable as a setting in almost every digital camera. Today, you can approximate the film look on a camera costing a few hundred dollars. I cannot tell you how lucky you are to be getting into this today! When I was getting my start, we were shooting on VHS cameras, and the gap between what was possible for us and what was possible for a "real" movie was never wider. If you think you need that super-expensive cinema camera, keep in mind that for almost all film students, the camera is never the obstacle to making a quality film. Focus your energy elsewhere; gaining access to equipment is no longer a good reason to go to film school.

4. EVERY MOVIE AND BOOK IS AT YOUR FINGERTIPS

Classic, avant-garde, and generally obscure films used to be hard to get your hands on. The school's archives, once upon a time, were a great way to see movies you couldn't see anywhere else. But 99 percent of the movies you'll see in film school today are available online (or even on "old-fashioned" media like DVDs). Many film schools have excellent film libraries, including out-of-print films, but in the face of six figures of debt, seeing a rare 35mm print of a classic is a luxury, not a game-changer. In addition to film libraries, book libraries have also moved online, and that gives you the ability to create your own critical studies course. A few trips to Amazon—be sure to check out the topical user-created lists—and you can get yourself a set of film history and theory books. You can even also browse many syllabi online and read the exact same books they're reading in the high-priced classroom . . . on your own. Access to a physical library is no longer a good reason to go to film school.

5. A FILM DEGREE IS OPTIONAL

It's easier to justify the cost of a specialized graduate program in a field that requires a specialized degree: for example, if you didn't get a law or medical degree, good luck starting your own practice. But no one puts "directed by so-and-so, PhD" in the credits. At least if you graduate from law school, the job applicant pool will be narrowed down to others who also spent a lot of time and money passing the bar. If you graduate from film school, on the other hand, the job applicant pool will consist of other film school

graduates like you . . . and everyone who didn't spend any time or money on film school too. You're putting a lot of stock in that one line on your resume.

Finally, unlike lawyers or dentists, the vast majority of filmmakers don't make a lot of money. Offsetting the cost of your student loan is a lot harder when you can't bill $500 an hour for a legal consultation or $2,000 for putting a crown in someone's mouth. Often it takes years of grunt/free/spec work to work your way up to a well-paying film gig. Paradoxically, what this means in practice is that a lot of more lucrative, non-film jobs are going to end up looking more attractive after you graduate from film school because of the debt attached to your expensive film degree.

6. NOT EVERYONE LEARNS BEST IN THE CLASSROOM

Different students learn best via different methods. Some are visual learners, others auditory. Some need guidance and encouragement, while others thrive when left to their own devices. Personally speaking, I was never a great student in the context of a classroom environment. After graduating from college with a decidedly average GPA, however, I learned that in the context of the real world it turns out I'm a very hard worker. There was something about the classroom—or more likely, something about being told what to do by an authority figure—that failed to motivate me. I knew that I would be better off cutting my teeth outside the insular environment of the classroom—but that is not true for everyone. Think less about general debates (like this one) about what is "best," as there is no one-size-fits-all approach; instead, focus on your own personal needs by examining and acknowledging what kind of learning environment is best for you.

7. LESSONS AND ANSWERS CAN BE FOUND ON WEBSITES, FORUMS AND DVD SPECIAL FEATURES

Film used to be an industry where the secrets were closely guarded. Movies were considered magic because so few people actually understood how they were put together. But since the advent of DVD special features and behind-the-scenes breakdowns, the doors have been blown open to anyone to discover how a film is made. Don't underestimate the impact of director's commentaries and "making of" features . . . which are not tied at all to film school.

Similarly, you can learn a lot about film online, where some of these behind-the-scenes materials live today (with the demise of the DVD). I won't name any websites here, because I happen to run one designed explicitly for this purpose—it would be like an athlete telling you that the secret to running faster is to wear the shoes he or she endorses—but suffice to say, Google is your friend. Beyond tutorials and case studies and interviews, the Internet also offers a great place to ask any questions you have. For example, I once didn't know how to write an expression in Adobe After Effects, so I posted my question in an online forum for filmmakers. A fellow filmmaker showed up and not only helped me with the issue—he actually wrote the expression for me. It was amazingly helpful, and I would've been hard-pressed to find a classmate who had that expertise. At this point I probably sound like a broken record for touting the Internet so much, but it is the most important invention of our lifetimes, so here's one more for good measure.

8. AN ONLINE NETWORK

Of Jason's ten reasons to go to film school, I personally think #7, "A Professional Network," is far and away the most important benefit to going to film school. Capable and collaborative classmates are tangible benefits you can see and touch for years to come, as opposed to abstract concepts like "knowledge" and "craft." Just kidding (and don't touch your classmates unless they want you to). However, if you live somewhere where you're not able to find proficient, like-minded collaborators, that to me is the largest obstacle to getting work made in your current locale. This was the reason I left my home state of North Carolina and moved to New York.

But . . . again, there's this thing called the Internet! Millions of people network and even find work through social sites like Facebook, Twitter, Vimeo and yes, No Film School. I felt my physical location was important, thus I moved to New York City, but you don't need to pay a school in order to pack up and relocate. Instead, I used the Internet to network and got hired at MTV. Not everyone will be so lucky—but any time you can get paid to learn, that is a better route to new opportunities than accumulating debt.

9. YOU'LL PROBABLY MAKE IT (OR NOT) EITHER WAY

Media titan Barry Diller once said, "There's not that much talent in the world, and talent always outs." Which is to say, if you're going to make it, you'll find a way—regardless of how long it takes, and regardless of the

particular obstacles you encounter. Film school can help you become a better filmmaker—it can refine what's already there, and it may accelerate your development (and debt)—but if you don't have the motivation and grit necessary to overcome the disappointments and failures you are sure to encounter, even the most prestigious degree won't help. If you've got what it takes, you'll eventually make it, whether you go to film school or not! In light of that logic, it's harder to argue for paying to learn (in a school) over getting paid to learn (in a job).

10. THE MOST INSTRUCTIVE SCHOOL IS THE SCHOOL OF HARD KNOCKS

They can teach you in school how to say what you're trying to say, but they can't teach you what to say. With the six figures you're likely to spend on film school, what would happen if you instead spent that traveling the world, reading a lot of books, doing odd jobs or volunteer work and meeting a lot of people along the way? Your perspective on the world is more important than any amount of craft or production value. If you skip film school to travel the world, and you're insecure about your understanding of the 180-degree rule, read the Wikipedia entry on it and be on your way. If, in the course of your travels, you discover that you're not interested in being a filmmaker after all, that's probably for the better too, because you would've realized that eventually—this way you didn't spend all of that money on a degree in film first! Live life and discover what makes you unique—that is something no school can give you.

If these reasons helped push you toward not going to film school, great! If after reading these reasons, you still feel like film school makes sense for you, also great! There is no right answer that applies to everyone.

If you are going to film school, my one piece of advice is this: Don't think you're better than anyone. If you look around the classroom and think you're the best writer/director/DP/editor in the room, forget about it. Plenty of people with more talent than you have failed in this difficult industry. Unlike a sport like track and field, for example, there are few ways of objectively measuring and rewarding ability in film—and it can be incredibly difficult just to gain access to the track, as it were. It might take decades to find your niche, approach and voice, so if you're enrolling in a film school (or not, for that matter), my advice is to stay humble . . . and make friends.

Ryan Koo, Filmmaker and Founder, No Film School

Graduate or Undergraduate Film School?

Anyone who decides to become a director is risking the rest of his life, and he alone is answerable. It should be the conscious decision of someone mature.
Andrei Taruovsky, *Sculpting in Time*

The question of graduate versus undergraduate film school comes down to three factors: money, maturity and timing. Each factor is unique to every individual. As with any major life decision, this section is less about giving answers than properly stating the questions. Let's examine each individually.

1. MONEY

An undergraduate education may be cheaper than a graduate one for many reasons. Many schools charge less tuition and offer more financial support for undergraduate students, and, at least in America, many parents save money to send their kids to college.

Film school is very expensive. This is a reality we all have to face, and one I have dedicated an entire chapter (see Part 4, Chapter 1) to in this book. It's important to understand that living with a high level of debt will permanently change the course of your life, and probably delay major life decisions including having kids, owning a home and sleeping eight hours straight at night.

2. MATURITY

As an undergraduate, you are often learning how to be a human being that is no longer fed, housed, financed, disciplined and protected by someone else (i.e. your parents). This is a hell of a journey that only begins with the time you spend in college. As a graduate student (again, ideally), you've taken a few licks in the real world and overcome many of life's obstacles. As a slightly older person, you've also hopefully developed some opinions about the world that can shape and enrich your work, as well as had some job experience that taught you some professionalism. All of that maturity and experience will serve you well going into the incredible obstacles you will face as someone who wants to work in entertainment.

If you're in your early twenties, you might consider not applying to film school until you've given yourself some time to gain some maturity. When I was 22, I made the conscious decision *not* to apply to film school, because I didn't feel mature enough yet. That being said, I have screened at major film festivals with 22-year-olds who feel more mature than I do at 30. Filmmaking is a craft that is done by human beings (part of what makes it attractive), and each person is different.

What's important to understand is that becoming a filmmaker, in terms of workload, risk and difficulty, is easily on the level of founding your own business, law firm or other professional practice. Law and med students take on a similar debt load for a more secure understanding of how they will earn their money. Entertainment is an intensely competitive, initially underpaid industry; you often only get one first impression.

Keeping all that in mind, consider some of the following questions: Would you consider yourself a mature person? Would you benefit from taking some time to grow up and work some jobs before you dive into the hardest choice you'll ever make? Just as important, what life experience can you bring to filmmaking? What do you have to say about the world?

Undergraduate and graduate film school are very similar in terms of their curriculum and the skills they teach. The major differences between the two are the life experience of the people being taught, and how much it costs to attend them. The danger in undergraduate school (which is just as possible in graduate school) is that you'll spend years learning the language of filmmaking, only to find that, with your lack of life experience, you have nothing to say with it.

3. TIMING

Filmmaking is a tremendously difficult craft, which takes even our greatest filmmakers decades to master. As proof of this, the student films of some of the world's greatest filmmakers are often available online, at least until their respective filmmakers pull them down. Personally it took 7 years and 11 short films between the first film I made and the one that played at major festivals. This journey was very different from 21 years old, when I started, to 28, than it would have been say, from 31 to 38 or beyond.

A 22-year-old graduates into the world from a very different life position than a 30 or 40-year-old. An advantage to being so young when you graduate is that you will have time to work your way up through the low paying jobs at the bottom of the industry. Another consideration is that the older you are, the more difficult it is to delay major life decisions like having kids, buying a home or foregoing the security of a monthly paycheck.

To put it another way, a life in the arts is composed of more questions than answers. It's a paradox: the lack of a road map means excitement, engagement and creativity, but also insecurity, doubt and despair. You cannot have

one without the other. Filmmaking, like all the arts, demands a great deal of faith from those who pursue it.

This section presents the situation from ideal circumstances; most people do not consider film school from the perspective of a high school student applying to college. Use the ideas in this section to reflect on your own particular situation and what it means for you.

The Film School Majors This Book Addresses

Now we come to the specific live-action film majors that are the focus of this book.

1. DIRECTING

Most prospective students see themselves as directors, if only because it's the best known position on a film set. In collaboration with the producer, the director "hires and inspires" a group of fellow creative artists, including the cinematographer, actors, key design collaborators, editor, composer and so on, all while keeping them within the framework of her own specific vision for the film. This is a craft that takes decades to master, requires tremendous people skills and an equally tough will. Film school is a great place to begin the process of achieving mastery, because you will be given many opportunities to make films and analyze what worked and what didn't. While this is undoubtedly one of the most popular majors, it is also one of the most expensive. Most schools only partially fund student films; the director often personally makes up the difference. Many people also enter this major only to find that their skills and passions lie in another field. Directors generally spend several years developing, financing, shooting and completing feature films. Directing can thus be a lonely profession, and one that requires tremendous patience and self-discipline.

On a final note, many students go to a top film school thinking that after a few years they will direct a studio film. This is simply false. By default, upon graduation all directing students are independent filmmakers, until the rare moment a studio decides they're worth offering employment. This usually comes after a filmmaker has made one or several films independently that prove their ability to handle such a large project.

2. CINEMATOGRAPHY

The cinematographer is the person directly responsible for the look of a film. On a large film set, the cinematographer generally manages two sets of crews: one responsible for the lighting, and one responsible for the camera and its movements. This is an incredibly visual, creative position that generally requires strong people skills and great visual thinking. Professional cinematographers either work their way up through the ranks of film crews, or go to film school, where they ideally shoot a lot of student films. In film school, it's also very important for cinematographers to have good people skills to build relationships with the directing students, who will take them on to

shoot their films. On a shoot, if the dailies are crap, the cinematographer is the first one to be fired.

An essential if little-known position on a film set, a great advantage of cinematography is that, unlike directing, you are only on a shoot for some prep and then the production. This means that a successful cinematographer can often work on multiple projects in a year. If you're talented and get along with people, this can also be one of the more lucrative positions. It is essential for aspiring cinematographers to make it to an industry center, where they have the opportunity to meet aspiring directors and shoot their projects. As mentioned, film school is one excellent way to do this.

3. EDITING

For many aspiring filmmakers the role of the editor is relatively unknown, but make no mistake, it is an essential creative position. The editor, in collaboration with the director and producer, authors the final film through the selection of shots and their arrangement. This is an awesomely powerful position, and a truly creative one. A few schools offer editing programs, which will again allow you to gain countless hours of practice by editing fellow students' films. The professional editing world still has an excellent apprentice system where young people can move up from editorial intern to assistant editor to editor. Like screenwriting, this is a way to get a lot of experience in film storytelling without having to finance expensive student films. Like cinematography, aspiring editors need to be in an industry center, where there are multiple potential projects for them to work on.

4. PRODUCING

Producing is an often misunderstood major in film, perhaps because it is such a vast and often vague set of responsibilities. There are also many variations on the title of producer. In a classical sense, a producer is the originator and shepherd of the film, often developing an original idea or acquiring the rights to a novel or article, then hiring a writer, overseeing the development of the story, and continuing on through the financing, casting, crew hiring, production, postproduction, completion and exploitation (i.e. earning the money back) of a film. The lead producer on a film is a key creative collaborator, who negotiates between the financiers, director, key creative positions and the reality of a film's budget. Successful producers live by their professional network, and also have excellent people skills.

This can be a very noble calling, but there seems to be a false belief that, because of its relationship to the business world, producing is somehow safer than the other creative majors. Producers take just as many risks, creatively and financially, as directors or anyone else. Put briefly, this is not the "safe" major for people who are afraid to go into other disciplines. If you are entrepreneurial, have great people skills, are creative and extremely hardworking, this could be a great major for you.

5. SCREENWRITING/TELEVISION WRITING

The screenwriter is the shaper of a film story. Feature screenwriters spend a lot of their time alone developing stories, writing scripts, deciphering feedback and revising their work. In UCLA Film School professor Howard Suber's essential book *Letters to Young Filmmakers*, he discusses a less seemly part of being a screenwriter: they're often treated like shit. Suber goes on to give three reasons why this might be so:

> (1) everyone thinks he is a writer, (2) the writer leaves the job early, and (3) sometimes the writer deserves it.

A studio screenwriter, like a member of a medieval court, must constantly interpret and implement the notes from stars, studio executives, development executives, directors and others who hold tremendous power over which movies get made and which ones land in "development hell." Like the courtesans of old, much of a Hollywood screenwriters' career will be spent learning to interpret these powerful people's behavior, as well as what they actually want from a writer.

This is part of why some screenwriters try to move into directing later in their careers. But know this: it's a herculean task to build a successful screenwriting career. To then transition to a successful directing career is even rarer.

Screenwriting is a remarkable, difficult and essential part of the filmmaking process. It's also far more affordable than a directing major, because you don't have to finance student films.

The culture of television writing is very different than features. In television, writers work in groups and have far more power than in feature films. Television is generally considered a writer's medium, while feature films are the preserve of the director. Television writing also has a clearer hierarchy and apprenticeship system for writers than feature films. A showrunner is the creative head of a television show, a role that combines the responsibilities

of a writer, executive producer and script editor. Certain schools offer tracks specifically designed for aspiring showrunners, so if this is your dream, they are certainly worth looking into.

For both kinds of writers, it's pretty essential to be in Los Angeles. This is the city where the agents, managers and development executives who control the flow of knowledge, power and opportunity are based. Film school can again provide the impetus or opportunity to relocate.

Before Film School

Know what the old masters did. Know how they composed their pictures, but do not fall into the conventions they established. These conventions were right for them, and they are wonderful. They made their language. You can make yours. They can help you. All the past can help you.

Robert Henri, *The Art Spirit*

Develop Your Voice

There are many, many things you can and should do to prepare yourself for film school. Once you're there, you'll quickly realize how short two to five years really are. Any film or life experience you can get before you go will be of value. I waited three years between undergrad and graduate film school, in which time I watched a lot of movies, did a lot of reading, did a Fulbright scholarship, interned for film companies, worked several jobs, lived abroad and made three short films. While much of this time was difficult and confusing, in retrospect I wouldn't trade this experience for the world.

This chapter will break down a number of things you can do to prepare yourself before you go to film school, including an intense amount of reading and viewing. It may seem like a lot of work, but as a storyteller you are asking people for their time and money in exchange for what you have to say. It's an awesome responsibility. The filmmakers you admire know the history that came before them, and you cannot get by on just Christopher Nolan, Quentin Tarantino, Steven Spielberg or whoever the current hot young director is. Your movies will suffer.

So how do you prepare yourself to go to film school?

1. AREAS OF MASTERY FOR FILMMAKERS

As someone who wants to master the art of filmmaking, you are not unlike someone who learns to become a concert pianist or, as mentioned, an Olympic athlete. In order to achieve mastery, and hopefully build a career for yourself as a creative person, there are four broad areas you will need to focus on.

1. Master Yourself

You will always be the front lines for any creative choices you make. You are the one who will choose what kind of stories you want to tell, how you want to tell them and who you want to tell them with. This first chapter in particular is going to focus on things you can do to start mastering yourself, which includes:

a. Your Taste

What kind of stories move you? What kind of stories would you like to tell? This is going to come from reading and watching a lot of different things to see which ones resonate with you, as well as creating a lot of your own work.

b. Your Creative Process and Habits

What gets you to the desk in the morning? What motivates you to create work? What is your creative schedule like? If you can't show up every day and do the daily work of writing a screenplay, finding and working with collaborators, creating a visual plan, you'll never become a filmmaker.

2. Master Your Craft

These are all of the creative and technical aspects of making your work. This knowledge comes from a mixture of theory and practice, both of which you will get in film school. Some examples:

> For screenwriters: formatting, diction, grammar, structure, character arcs.
> For directors: directing actors, breaking down a script, developing a visual language.
> For cinematographers: visual storytelling, including lighting, framing, camera movement, equipment.
> For producers: developing stories, business plans, pitches.
> For editors: the technical software, how to organize footage and assemble sequences.

3. Master the Art of Collaboration

For all of these disciplines, the ability to collaborate is central. If you study the IMDB credits of different films, you will see that the number of cast and crew members often ranges from 200 for small independent films, to 3,000 and beyond for studio blockbusters. That's a lot of collaborations!

From screenplay to movie theater, a film goes through many rounds of feedback and revisions. Your ability to choose collaborators and projects, as well as to give, receive and incorporate feedback from others, will be central to your ability to learn and succeed as a filmmaker. Just as important is the ability to motivate and inspire your fellow collaborators to do their best possible work. This is a deeply human process, one that takes years to master.

4. Master the Industry

Film is an inherently collaborative medium; just look at the end credits for any major film to see the armies of people who worked together to make it. A strong and diverse professional network will be key to your success as a filmmaker. Top film schools are often criticized for not giving enough access to professional opportunities; this is nonsense. Real opportunities in the

film world generally come through personal referrals. If something turns up on a job board, it means that the person could not find someone through their personal network. Initially through internships, and, hopefully, later through paid work (much of which will come through your ever-expanding network), you will be able to see how opportunities in the industry are channeled through an endless series of private networks.

If you want to be any kind of filmmaker, do not try this alone. So many people try to build their filmmaking careers by themselves; it just doesn't work. You need a solid group of collaborators to make a successful film. This is one of the reasons most filmmakers ultimately move to New York or Los Angeles; being surrounded by crazy people like yourself, people who want to make films, is essential to getting films actually made.

Another word for it is a *community*.

2. DIG YOUR CREATIVE WELL

As an aspiring filmmaker, you will probably start out making short films and writing short screenplays. This is a good thing, because the hard truth is that most of your early work will not be very good. For directors, shorts are better than features for one simple reason: a feature film might take you years to make and have the same educational value as a single short, which takes a lot less time, money and despair to complete.

Film schools focus on short films for the same reasons: their education value and production feasibility. As you begin making films and writing screenplays, try to view them not as works of art but as exercises through which you can practice and hone your skills.

To train your mind as a filmmaker, you need to dive into the history of cinema, art and dramatic storytelling. How can you get started? What follows are a series of lists, which include the classics of American and world cinema. All of these lists can be easily found online. If you are fortunate enough to live in a city with a repertory cinema, go see the classics on the big screen! There's nothing like it, and the commitment involved in going to a theater will force you to pay better attention and actually finish the film (which is not always easy).

1. Feature Films

1. AFI 100 Greatest American Films
 This is the canon of American filmmaking. As good a place to start as any.

2. Sight and Sound 100 Greatest Films of All Time
 This includes more world cinema. Watch as many as you can. Watch the films that you find difficult. Learn to articulate what you find good and bad and why.
3. The Criterion Collection
 This is an excellent DVD collection of the great and varied history of cinema.
4. Documentaries

Jean-Luc Godard once said that "all great fiction films tend towards documentary, just as all great documentaries tend toward fiction." There is a wealth of knowledge to be gained through documentaries, regardless of whether you want to make them. PBS's *POV* (Point of View) program has an excellent list of 100 great documentaries on Netflix, included in the resources of this book.

2. Short Films

I was consistently baffled in film school by how few people, directing students in particular, watched short films. Short films are an inherently different storytelling form than features. You should watch as many short films as you can, and again try to articulate what you find good and bad about them. If there is one thing that all film students can do to improve their filmmaking, it's improving their grasp of short-form storytelling. It will do wonders not only for your film school experience, but for your life as a filmmaker.

It's also helpful to see the early work of directors you admire to help you understand that they all started somewhere. Chris Nolan, Robert Rodriguez, Lars von Trier and countless others all have early short films available to watch.

Here are some short film resources:

1. Short of the Week
 This is a site that features the best in online short-form storytelling. You can even search by which festivals the films played at, and which film schools the directors attended. This is an invaluable resource for filmmakers. As an exercise, try to find five short films that you find truly excellent, then articulate to yourself why they're great.
2. Cinema 16
 Cinema 16 has released an excellent series of DVDs that, among others, feature the early short films of acclaimed directors like Ridley Scott,

Guillermo Del Toro, Park Chan Wook, George Lucas, Lynne Ramsay, Tim Burton, Gus van Sant, and many more. Find them and watch them. There's no better encouragement than seeing the early work of a filmmaker you admire.

3. Vimeo Staff Picks

This is another high-quality online platform for short films, music videos and other online short-form video content. There are always good things in here, and you can very often see which festivals the films played at.

When you see a filmmaker's work that you like, get in the habit of checking out their IMDB profile to see if they made any short films. Very often you can find their early work online or in a DVD collection. It's a helpful reminder that everyone, including your idols, started somewhere.

3. Festival Films

Another great habit is to see the films that play at major festivals. As the Video On Demand (VOD) distribution model takes over independent film, more and more festival films are available to watch online. Most filmmakers get their start with festival films, which, with their lower budgets, are more accessible to young filmmakers than major studio fare.

4. Television

Television has entered a golden age, to the point where some say it has surpassed the feature film. One great history, which has an excellent list of shows to get you started, is Alan Sepinwall's *The Revolution Was Televised*. The book tells the fascinating story of how television came of age in the HBO era, and features the following shows:

1. *Oz*
2. *The Sopranos*
3. *The Wire*
4. *Deadwood*
5. *The Shield*
6. *Lost*
7. *Buffy the Vampire Slayer*
8. *24*
9. *Battlestar Galactica*
10. *Friday Night Lights*
11. *Mad Men*
12. *Breaking Bad*

Working through these shows will give you a basis in modern television. If television is your passion, make sure to go deeper into the history of the medium.

5. Read Screenplays

If you want to make films, you absolutely need to learn the art of screenwriting, including how screenplays are structured, formatted and composed. In the Internet age there is almost limitless access to the greatest screenplays in history. Many great writers learned screenplay format not only by reading screenplays, but by literally transcribing them. Set yourself a goal to try and read 50 screenplays before you start film school. This is an invaluable way to see how films are written, which is very different than fiction or other writing styles we're more familiar with. Also, when you see a great film, go back and read the script to see how the writer communicated his or her vision on the page.

A great resource for the history of screenwriting is the Writers Guild of America (WGA) list of the 101 Greatest Screenplays. There is excellent overlap between this and the AFI 100 Greatest Movies list. Make sure to read modern screenplays as well, as the form perpetually develops. For a fascinating and essential look into the history of screenwriting, check out *What Happens Next: A History of American Screenwriting* by Marc Norman, the Academy Award-winning writer of *Shakespeare in Love*.

6. Read the Great Writing of Our Species

This means great drama, literature, history, philosophy, nonfiction, journalism and beyond. Your work will only be as good as your knowledge of the traditions of storytelling and the human condition in general. When David Simon wrote *The Wire*, widely considered the greatest television show in American history, his main inspirations were his multi-decade career as a Baltimore crime reporter and his fascination with Greek tragedy, in which he saw a powerful metaphor for our troubled times. These provided both an experiential and a dramatic lens through which he created one of the most important shows in the history of television. It wasn't just because he'd seen a lot of Steven Spielberg movies or made his way through all of the *Grand Theft Auto* series (though both of these are awesome).

Sophocles, Shakespeare, Dostoyevsky, Toni Morrison and others are the backbone of how and why great stories are told. In them you will find the blueprints for thousands of stories and characters you've already seen.

A good place to look for the canon of world storytelling is the Norwegian Nobel Institute's list of the 100 Greatest Works of World Literature, which is listed in the resources section of this book.

Yes, it is important to understand movies and television, their history, how their stories are written and structured, and how they reflect each other. But you will do yourself a disservice if your creative well is only a century deep. It behooves you to develop an insatiable curiosity not only about film, but about the world in general.

Another important source of information and reading is your daily newspaper. Use it and the other reading and viewing material to slowly form your own understanding of our place in the world. That is how you will continue to deepen the well, and one day, when you're searching for the words and images to express yourself, they will be there, as if by magic, waiting for you.

7. Study the Great Visual Work of Our Species

In the great documentary *Visions of Light*, we meet some of the heavyweights from the history of cinematography: Vittorio Storaro, Conrad Hall, Vilmos Zsigmond, Sven Nykvist, Haskell Wexler and more. These are the men (unfortunately this field is still male-dominated) who photographed some of the greatest films in history. What you will notice if you listen to them talk is their knowledge of visual art.

Vittorio Storaro, cinematographer of *Apocalypse Now*, *Last Tango in Paris*, and *The Last Emperor* wrote an extensive treatise on the use of light in painting and photography. Darius Khondji, who photographed films as varied as *Se7en* and *Midnight in Paris*, always carries a copy of Robert Evans' seminal photography book *The Americans* with him when he shoots. Painters like Edward Hopper, Johannes Vermeer and Rembrandt have influenced generations of cinematographers and directors.

Your knowledge of the world's visual art, including photography and painting, will only deepen the well you draw on as a creator.

8. As You Progress, Pick Five Works of Art That Move You and Study Them

A fellow film student once made a really good student film. It stood out like a small marvel among our many confusing and half-formed creations. After her screening, she got the usual question from her friends: How did you do it?

This question has many answers, but here's one of them. This film-maker watched *Breaking the Waves* by Lars von Trier 40 times. She watched it with the sound on and off, she watched it until the story melted away and all she saw was the raw filmmaking. At one point, something in that film spoke to her, and she worked her way through it until she finally understood what it was so well that she could articulate it in her own film. Her own film was not a rip-off; it was an original, moving story that was inflected and deepened by what she learned from Lars von Trier's film. None of us would have seen the reference if she hadn't told us.

As you continue to study the creative work that came before you, certain pieces will seize you. When this happens, take extra time with them. If it's a film, watch it over and over to see how it's made. If it's a photograph, study it intensely. Same for novels, plays and nonfiction. Find the other work by these artists; read their biographies. When you fixate on a work of art, it very often reflects a core theme in your life. Spend hours poking at these wonders; you will find untold riches in them.

As you keep working, you will find that this list changes. Repeat the process. Never stop learning. The question, addressed earlier, of choosing graduate versus undergraduate film school, is also about the depth of your well and your ability to dig deeper. The goal is to become the eternal student. Film school, whether you attend one or not, is only the beginning.

3. SELF-OVERCOMING: DISCIPLINE, COURAGE, PERSEVERANCE

> *The most common lie is that with which one lies to oneself;*
> *lying to others is relatively exceptional.*
> Friedrich Nietzsche

Before you go to film school, it is essential that you make some work. This will be important not only for your applications, but also for your personal development as a filmmaker. Writing screenplays, taking photo series, making a short fiction or documentary films will be the best way to teach yourself what kind of filmmaker you are, where your strengths and weaknesses lie, and what specialization (screenwriting, cinematography, etc.) you might be best suited for. Just make sure to finish whatever you start, otherwise the learning potential is diminished.

It's hard to get off the couch and start making things, so here I will turn to Friedrich Nietzsche, a celebrated German philosopher from the 19th century, who had a lot to say about the creative life and process.

The idea of self-overcoming (*Selbstüberwindung*) is central in Nietzsche's philosophy. Nietzsche had a hard time figuring out why humankind so consistently failed to achieve its potential, but he managed to narrow it down to two things:

1. Laziness
2. Fear

Seem familiar?

To these two I would add one more. One of my favorite professors was once asked what the single most important characteristic that all his successful students (including Alexander Payne and Francis Ford Coppola) possessed.

He took a weekend to think about it, then came back with his answer: the ability to deal with despair. The film industry has all shapes and sizes of despair on offer, as you will no doubt experience as you continue on your path. Also, as you'll learn, everything's better in threes.

So let's look at the three universal traits that prevent people from making films, or any creative work for that matter:

1. Laziness
2. Fear
3. Despair

These are the true enemies if you want to do creative work. Notice I didn't say "not having the last name Coppola," or, "not being a straight white Protestant man," or "not having an agent or manager." Those are all very real obstacles, but none of them matter if you can't overcome your own inner obstacles. Hence, self-overcoming. "The man" doesn't tell you to watch HBO instead of writing your screenplay, that's on you.

So what characteristics do you need to develop to become a filmmaker? I believe that there are three, all designed to counter those evil bastards up there.

1. You need the DISCIPLINE to create your work.
2. You need the COURAGE to put it into the world.
3. You need the PERSEVERANCE to keep fighting and improving in the face of rejection, indifference and despair.

Each of these virtues will help you in the myriad difficult situations you will encounter along the road.

Regardless of whether you go to film school, if you base your life around these principles, you will become a filmmaker. No one can guarantee that your films or screenplays will be successful, but they will exist. Keep these principles in mind as you start to develop your own creative projects.

4. GET ORGANIZED

> *Luck is the residue of design.*
> Branch Rickey

When you choose a creative career, you commit yourself to having two jobs:

1. The job you do for money (i.e. to eat food and not die).
2. The job you do for love (making films, writing scripts, etc.).

In order to do both jobs effectively, you will need to be extremely organized. The reality is that for the first decade or so you write screenplays, you will probably not get paid for them, or will be paid so little that the number of hours and anxiety you invest will be far below minimum wage. This means that as the CEO of your film career incorporated, you have to become an expert in self-management. Know now that the odds are low that your parents, your friends and the rest of the world will understand your new job, or its ridiculously low starting salary.

A short film, spec screenplay, pilot script, web series or low-budget feature film often represents thousands of hours of unpaid, unappreciated labor. In this case, improving as a filmmaker has to be its own reward. Film school will create a structure in which this process is taught, legitimized and funded (usually against debt), but the center of the process is you and your ability to actually make things.

There are various strategies to getting organized, but there are generally three major components.

1. Set Overarching Goals
In your quest to become a filmmaker, there will be thousands of little steps throughout the process, and it can be very easy to lose sight of what you're actually trying to accomplish. This is why it's important to write down your goals, and set time periods in which you would like to achieve them. Then

you can evaluate your day-to-day and week-to-week choices against what you're actually trying to accomplish. Take time every few months to sit down and write out a list of goals for the next three months, six months, one year and five years of your life. Keep that list someplace visible, where you can see it. This will not only allow you to evaluate your daily activities against those goals, but to hold yourself accountable for achieving them.

2. With Those Goals in Mind, Learn to Make To Do Lists

There are many different productivity apps today that create to-do lists. Whenever you have something you need to do, from applying to film school, to watching a movie, to everyday errands, learn to write down a "To Do" in your app or on your paper list.

I will go into more detail on this later, but one important thing to know is that you have to break creative projects into simple, actionable steps. Instead of putting down "write a feature," you should break that process down into the smallest steps possible. Instead of the result you want to achieve, focus on the steps you want to take and when you want to accomplish them. An example of a task that would lead to writing a feature would be: "complete a character tree for my protagonist," or "write a one-page outline." Give each of these a date you need to complete them by, and put them in your calendar. If you break a process into actionable steps and a timeline, you will be much more able to answer the question of "so what do I do right now?"

The essential principle behind these to-do lists is that you need to get these tasks out of your head and onto a list, so you can simply complete the tasks without worrying about organizing them or forgetting one. Mihály Csikszentmihalyi is a Hungarian psychologist who has popularized the concept of *flow*, which is a mental state where a person performing an activity is fully immersed in a feeling of energized focus, full involvement and enjoyment in the process of the activity.

If you're lucky, you've experienced flow in your life: it's when you lose a sense of time while performing a creative task. Hopefully you've experienced it while watching films or television; sometimes it seems like three hours have passed in five minutes.

Flow in creative work, be it writing a screenplay, directing a film, composing a shot or editing, usually comes from a deep place of preparation

and organization. It is hard to really lose yourself in a task if your mind is focused on trying to remember something you need to do. Multitasking is also death for this, so learn to carve out distraction-free "sacred time" in your day to do these things as well.

If you're having difficulty turning off the Internet to write your script, film school application or other creative work, I recommend an app called Freedom, which turns off your Internet connection for a set amount of time. I generally use it when I'm at that über-difficult beginning of a creative project (including this book).

3. Schedule Time to Complete Your To Dos, Then Actually Complete Them

The calendar is the final part of this oversimplified look at personal productivity. As you generate your large To Do lists, it's important to schedule out time to complete each task, keeping in mind any important deadlines. As you progress in your creative life, you will find that many projects you take on will not have any fixed, external deadlines. It will thus be up to you to decide a reasonable amount of time to complete a project, and then stick to it.

As you progress, continue to revise your goals, To Do list and calendar. If you can keep them in harmony, you will slowly progress toward your goals as a filmmaker. Strong organization skills combined with your creative ritual are what will sustain your creative career. Developing these skills before film school, when the costs are high and time is short, will be invaluable for you.

5. BUILD A WRITER'S ROUTINE

> *Routine in an intelligent man is a sign of ambition.*
> W. H. Auden

In *Daily Rituals: How Artists Work*, author Mason Currey analyzes the creative rituals of some of history's most successful artists, from Mozart to Kafka to Marina Abramovich. It's a fascinating look into some of the bizarre rituals people have invented to get themselves to the desk, studio or wherever they go to do their work.

While there is no magic secret to getting your daily writing done, here are a few ideas to get you started.

1. Pick the Same Time and Place Every Day

So much of creative work, particularly writing, centers around habits that prime the creative juices. Choosing a time and place that you go to every day will slowly transition your mind into a place where it spits out the good ideas you need to get your work done.

It's best to abandon now the fantasy of the creative genius who lives out his daily life, while waiting for inspiration to strike. All accomplished artists build their lives around some sort of daily routine. You cannot rely on inspiration to get your work done for you; it will be your perspiration that brings a screenplay from your head onto the page.

Studies show that the morning is generally better for productivity. Depending on your schedule, you can rise and hit the desk anywhere from 5:00 to 10:00 a.m. What's important is to be consistent and disciplined.

In Stephen King's excellent *On Writing: A Memoir of the Craft*, the novelist discusses his vision of "the muse." A muse is a creative force, generally personified as a woman, who is a source of inspiration for a creative artist. In *On Writing*, King describes a slightly different kind of muse:

> There is a muse, but he's not going to come fluttering down into your writing room and scatter creative fairy-dust all over your typewriter or computer station. He lives in the ground. He's a basement guy. You have to descend to his level, and once your get down there you have to furnish an apartment for him to live in. You have to do all the grunt labor, in other words, while the muse sits and smokes cigars and admires his bowling trophies and pretends to ignore you. Do you think it's fair? I think it's fair. It's right that you should do all the work and burn the midnight oil, because the guy with the cigar and the little wings has got a bag of magic. There's stuff in there that can change your life.

That basement guy might also be called your unconscious. Ask writers where their ideas come from and they'll often be hard-pressed to give you an answer. As you continue writing, you'll realize that while you can identify the roots of some ideas, others will remain mysterious. The only way to get them is to show up every day and do the work.

2. Find Solitude

To maximize your ability to get your writing done, you'll need to find—and sometimes create—solitude. Every writer will have a certain amount of

noise and movement that's tolerable, and you will have to experiment a little bit to find what works best for you.

You can try any number of environments, from your own apartment, to libraries and coffee shops, to see what gets your creative juices flowing.

It's important to remember that there is no such thing as a perfect writing environment, and that perfectionism can often be procrastination in disguise. The most important thing is to get the writing done.

3. Minimize Distraction

The Internet is a cancer of distraction for anyone trying to get serious creative work done. Especially when you're starting off on a creative project, you're probably going to need to turn it off. Fortunately, there are tools at your disposal. One program I find helpful for dealing with distraction is called Freedom. Freedom will turn off your Internet connection for a set amount of time. The only way you can turn it back on is by restarting your computer, a decision that is often quite humiliating. The program costs about $10 and can easily be found online.

4. Make Something Warm to Drink

Many writers immediately hit the desk first thing after they pour their coffee. Others are obsessive tea drinkers. There's something about coffee and tea that give people a much needed secondary task while they're working on something. Making tea can be a small, peaceful break while you're formulating a thought or find yourself stuck in a momentary rut.

5. Music (or Other Background Noise)

Many writers, including Stephen King, listen to music while writing. There's a great deal of variance in what people listen to. Some like music that could fit on the soundtrack for whatever they're writing. Others just like a peaceful background noise, like what you hear at a coffee shop, to keep them focused on the task at hand. Finally, some writers will listen to the exact same album every day while working on a project. Something about hearing the exact same thing helps them get into the creative flow.

Again, a little bit of experimentation will be necessary here to see what works best for you, but it's something to be aware of.

6. Work in One- to Three-Hour Sessions with a Break in Between

Most scientists studying creativity and mental work agree that one- to three-hour sessions seem to be the most effective for all varieties of daily work. If you study the routines of famous writers, many incorporate long walks or running into their daily routines. These can offer the opportunity for ideas to percolate away from the desk. When they return, they very often find that a difficult question they were working on has now been answered.

7. Set a Daily Goal (Pages or Words)

Especially early in your writing career, it's important to have set goals for the amount of writing you want to produce in a given day. Some examples would be 2,000 words of fiction, or five screenplay pages. These daily goals are important, because it can be very easy to walk away when you're in a difficult moment. As a writer you are both athlete and coach, and it's important to push yourself beyond your comfort zone. Remember, the miracle of writing is that everything can be rewritten.

8. Finish on a High Note

Many writers, including Ernest Hemingway, religiously believed that you should quit writing at the moment when you feel you know what's going to happen next. This allows you to always have something to start with the next day, as opposed to starting in a rut or someplace where you're stuck.

Unfortunately, this will not always be possible (no writer has only good days), so sometimes you will be approaching the same problem. If you get really stuck, sometimes going for a walk or sleeping on it will help your unconscious mind unravel the problems you're facing.

These are some ideas to get you started on your writing ritual. Remember that the most important part of any creative ritual is showing up, rain or shine, to do the work. As William Faulkner once said,

> I only write when I am inspired. Fortunately I am inspired at 9 o'clock every morning.

6. BUILD YOUR PORTFOLIO

This is the most important thing you can do as an aspiring filmmaker. I learned just as much from the films I made before film school, where I had zero knowledge or safety net, as I did from the ones I made in film

school, with all the accompanying guidance and support of faculty and fellow classmates.

It's important to set deadlines, make things, get feedback on them, revise, then finish. As you evaluate your work, take a hard look at your personal strengths and weaknesses. Are you good at writing? Directing actors? Cinematography? Be honest with yourself and try to design projects that improve on your weaknesses.

Treat these projects as exercises, designed to help you strengthen specific skills. A good way to make sure this happens is to set goals for each film or screenplay, such as, "I really want to get better performances with this film," or "With this screenplay I would really like to write better dialogue." As you identify weaknesses, examine books, movies and screenplays that successfully pull off the effects you're going for. Study their approach to the problem you're facing. If you're having trouble writing compelling characters, go back to Shakespeare, or *The Godfather*, and look at how those characters were written.

Paramount to this process is honesty: you must become a ruthless critic of your own work. At the same time you must be able to forgive yourself for your weaknesses and focus on improving them the next time around. Again, finish everything you start. It's the only way to maximize the learning process.

This process will often be very hard, and you will often fail. When you do, remember legendary screenwriter Charlie Kaufman's words:

> Failure is a badge of honor. It means you risked failure.

Filmmakers are rarely geniuses who realize fully-formed, perfect ideas. They tend to succeed not by creating a perfect plan, but by overcoming the endless obstacles that present themselves throughout the filmmaking process. Overcoming failure, suffering and obstacles is how you develop as an artist. Film school will not protect you from this process, it will simply facilitate it.

What a film school will also ideally do is give you a venue in which to go through the process over and over again, while surrounded by a supportive atmosphere and the constructive feedback of intelligent, encouraging and thoughtful faculty and peers. It makes failure easier, more productive and socially sanctioned, but it doesn't eliminate it.

Learn to appreciate the process, and you will continue to develop as a filmmaker.

7. REVISE YOUR WORK BASED ON FEEDBACK

Few are sufficiently wise to prefer censure which is useful to
praise which is treacherous.
La Rochefoucauld

The ability to solicit, process and incorporate feedback is one of the most important weapons in the filmmaker's arsenal. As Alexander Mackendrick says in his essential book *On Filmmaking,*

> screenplays are not written; they are rewritten, and rewritten, and rewritten.

Feedback is given at various stages in the filmmaking process and is one of the single most valuable aspects of film school. There will be more about feedback later in this book, but for now I encourage you to seek out intelligent friends and ask them for their honest opinions about your work. Send them your screenplay and offer to buy them coffee or a drink to talk it over. Screen your film with them in the room. Watch them: Do they shift in their seat? Furrow their brow? There's a magical process that occurs when you see your work with another person. What would you change now that you've gone through that process? Do certain parts feel long? Are they confusing?

Ask your friends for their honest opinion. Hold your tongue until they've finished speaking, then, if you feel so inclined, ask them questions to see if they understood your intentions. Write down what they say. Clarify certain things if you don't understand what they mean, but do not defend your piece or argue with them about it. Say thank you. Take a day off to give yourself some distance, then go back to the notes that you took and the piece that you're working on. Can you see what they mean? Are there changes you can make to better communicate your intentions?

Feedback is an essential part of the learning process. It is difficult, which is why it is important. Every time you make something, you have to evaluate your results against your intentions. Very often you will stray off the mark. Again, a willingness to be honest with yourself and to stare down reality will serve you endlessly in this process. Did you get the performance you wanted? Is the dialogue good? Did the story make sense? Why? Why not?

This is the essential process you will be repeating:

1. Conceptualize a project.
2. Make the project.

3. Evaluate its strengths and weaknesses with the help of trusted advisors.
4. Revise the project based on feedback.
5. Finish the project, warts and all.

Film school will help you understand this process better, mainly through practice, but the process remains the same.

P.S: If you find someone who is able to give honest, insightful, actionable feedback, cherish them. You often only get a few in your life.

8. TAKE A FEW CLASSES TO PREPARE

As you'll hear me say many times, film school goes very fast. Any basic knowledge you can acquire will be of great benefit before you go. Some classes at your high school, local community college or elsewhere will be of great benefit before you head into the hallowed halls.

As a bonus, after you apply to film schools, you will have to wait six to ten months before you start to hear any responses. A few classes will help to fill this time productively while you wait. Here are a few areas that are excellent for pre-film school study.

1. Screenwriting

Screenwriting is inherently different from fiction writing. Unlike a novel, most people never read screenplays in their daily lives. In addition to reading several screenplays, taking a screenwriting class (they seem to be offered everywhere now) will give you some basics in dramatic writing, as well as the formatting that is so specific to screenplays. It's always an advantage to have some experience going into film school, where you'll be surrounded by intelligent people who can give you feedback. Any basic knowledge of dramatic structure and basic formatting will be of great use.

2. Acting

Acting classes are also widely available and can be incredibly useful, particularly for screenwriters and directors. Even if you don't want to become an actor, learning the actor's vocabulary and tools will be a key part of your collaboration.

As a screenwriter, you will have to live as each of your characters while they pursue their goals. Understanding the actor's process, including ideas like objectives, actions and adjustments, will give you tools to help your characters become more realistic and alive.

As a director, the actor's performances are your responsibility, and there is no better way to learn what kind of direction is helpful, and what isn't, than sitting in the actor's chair yourself.

To help you prepare for an acting class, and to better understand what an actor does, *A Practical Handbook for the Actor*, written by six working actors, is a brief and essential window into the actor's craft.

3. Editing

Nowadays everyone feels like they can edit, but there is still a vast gap between the drag-and-drop home editor and the sophisticated editing software that most movies are cut on. Learning how that software works, all while learning how editing shapes storytelling, will be of great benefit when you enter film school.

4. Graphic Design

This one might seem a bit odd, but if you look at how many responsibilities the average filmmaker now has, a basic sense of graphic design is key. As far as branding goes, most filmmakers have at least a personalized website and business cards, but they also often do their own titles and posters for their films, as well as Vimeo and YouTube covers, Facebook pages and more. This extends as well into more basic items like resumes, which you will probably be sending out a lot.

The single easiest way to improve your image online and off is to have a sense of graphic design. Even if you don't do the work yourself, having a basic knowledge will allow you to more clearly articulate what you want to your designers, which will cut down on their hours as well as frustration.

One way to keep current is to follow graphic design blogs to be aware of visual trends; also, why not start a Pinterest board about your favorite movie posters? This will be of great help for the day you put together marketing materials for your film, and also teach you about visual communication to boot.

9. THINK ABOUT WHAT MAJOR YOU WOULD BE INTERESTED IN

As you go through the process of making films and writing screenplays, keep an eye out for the things that give you the most pleasure:

- Do you really enjoy composing shots and telling the story visually? Maybe that's a hint that you might be a good cinematographer.

- Do you relish the process of assembling the shots in the editing room? Editing.
- Do you love the difficulty of developing a story, then assembling a group of people and guiding them through the creation of a film? Producing.
- Creating a vision, then finding and inspiring collaborators to realize that vision? Directing.
- Shaping worlds, characters and stories on the page? Screenwriting.
- Suffering? All of the above!

If possible, try working in separate roles on friends' films. Offer to edit or do camera for someone else and vice versa.

Many people start out wanting to be directors, only to realize later that their skills and passion fall in other areas. Use your early films as an opportunity to explore those other positions. Listen to your inner voice, the one that tells you what you enjoy, what makes you curious, what excites you. You are the only one who knows what will sustain you.

Undergraduate programs generally incorporate a year or two where filmmakers rotate through roles before students decide on a specialization. For graduate programs, the applicants generally choose their specialization in their application. For graduate students, it's thus especially important to pick the specialization you're really interested in, because it will be very difficult, if not impossible, to switch majors once you've entered school.

10. GET A JOB

By this I don't necessarily mean a job in the film industry. Anything you can do that teaches you professionalism, discipline and maturity alongside gaining some valuable life experience is of significant value. What's important to remember is that you need to develop life experience in tandem with your film experience. Anything that challenges you and forces you to broaden your perception of the world is good. Lean into the difficulty. Rainer Maria Rilke, one of the world's great poets, once said "that something is difficult must be all the more reason for us to do it." This is a philosophy that can sustain a filmmaker.

11. DEFINE WHY YOU WANT TO BE A FILMMAKER

A couple of years ago I had lunch with a friend and her boyfriend in Los Angeles. The boyfriend had gone to a reputable film school and had

been living in LA for two years. He had been temping, in other words answering phones, booking schedules, etc. at several different agencies and production companies when their regular assistants got sick. He hated it.

He told me he was going to go to law school. He hated life in LA, and he had finally realized why he wanted to be a filmmaker: he thought it would make him rich and famous. He had spent four years in film school and another two years temping before he came to this realization. That's a lot of time and money.

Filmmaking is the worst possible strategy to achieve wealth or status. As I mentioned in the introduction, there are far more Olympic athletes than Oscar winners. People who make movies professionally are working or thinking about work *all the time*.

They spend very little of that time sitting in Jacuzzis smoking Cuban cigars. Even then, they're probably worrying about a rewrite on a script or why someone's not responding to an email.

This has to be something you live for every moment of the day, because that's what it will demand from you, forever. It's a form of fate. If that's how you feel about it, then good, embrace the difficult path ahead.

But please don't expect it to make you rich and famous.

Some good reasons to want to become a filmmaker?

A love of learning, storytelling, discipline, people, personal growth, collaboration and humility. A desire to live a life that forces you to face your fears every day. These are some of the remarkable things a life dedicated to filmmaking can bring you.

It's the kind of life that doesn't require a Jacuzzi. A shower should do just fine.

> Exercise: Write out, in one sentence, what you hope to achieve by becoming a filmmaker. (Bonus: This will help you when you're writing your film school application essays.)

P.S: I recently heard that the above-mentioned friend moved back to Los Angeles and has a new job in film. I guess it was more contagious than I thought.

Sidebar: The Big Choice: Film School, Film Work, or Just Keep Making Things?

As you continue making short films and writing short screenplays, you may feel like you hit a wall: your means no longer match your goals, you feel like you've run out of collaborators, or that your work would benefit from more professional experience.

When you're stuck like this, take a moment to consider the three major paths to becoming a filmmaker.

1. Film School

Very often, especially for people who want to become directors, cinematographers and screenwriters, this is an extremely helpful path. It gives you a structured atmosphere to continue the process that you've already begun: making short films and writing screenplays. As mentioned, film school is very expensive, so there are two more options as well.

2. Move to Los Angeles or New York and Work in Film

This is the other major option. If you have no contacts or relatives in these cities, this will be very difficult. It's never impossible, though. If you have a good attitude, an extreme work ethic, some savings and access to the Internet, this is the second option. You will do the path where you work a day job and moonlight as a filmmaker. Find collaborators and shoot projects on the weekends, join or form a writer's group, make contacts.

3. Stay Where You Are and Keep Making Films

This is another viable option. Is this just a temporary funk you're in? Have you seen continual progress in what you're making? Do you feel like you've developed a good network of collaborators? Have a strong voice?

Maybe you don't need film school. It is extremely rare for successful filmmakers to not have at least spent some time in New York or Los Angeles, but it is not unheard of. Make another film. Submit to festivals. Persevere.

You don't need to answer this question now. Go through the rest of this book, and give it some thought. Whichever path you end up choosing (and people often go through several phases), choose what feels right for you. Never look back; let your commitment prove its own validation.

Applying to Film School: General Research

What's the best film school? The one that brings you closest to your individual goals as a filmmaker.

The US film industry divides itself between New York and Los Angeles. Los Angeles is the undisputed center of the film industry, but if you look closely, a lot of young directing talent, especially those pesky Sundance filmmakers, come out of New York. Los Angeles is the home base of more mainstream commercial films, while New York tends to be the center of independent features. There are also a few smaller cities outside these two, such as Austin, that have vibrant independent filmmaking scenes.

This chapter will go more in depth on how to research film schools, as well as how to pick the one that might be right for you. For this to work, though, it will be important to familiarize yourself more with the film industry as a whole.

1. HOW DID THE MOVIES I LOVE GET MADE?

By now you should have begun a deep exploration of the history of cinema and television, all while keeping an eye out for the work that specifically moves you. Take a moment again to write out a list of those films and television shows.

Now, if you haven't done so already, you need to go back and research the careers of the people who made them. Look back through all their past work:

Did they go to film school? When? Where?
How many films have they made?
Where did they make them?
Where do they live now?
Do they still make films?
Do they have a production company?
Where is the production company based?

If they're American filmmakers, the odds are very high that they are based in Los Angeles or New York. There are always powerhouse regional centers like Austin, but, like any industry, the film industry has a center, and it's Los Angeles. If you haven't asked yourself already, this will surely be one of many times where you ask yourself if you should move to Los Angeles or New York.

The reality is that many of the best connections, opportunities and jobs generally, at least originate in those two major cities, and Los Angeles in

particular. This is not a global conspiracy against regional filmmakers, it's a simple fact of life: the tech industry is in Northern California, Wall Street is in New York, and Hollywood is in Los Angeles.

If you look at the independent film world, there are still many filmmakers in New York, to the point that *Variety* complained that this year's Sundance Film Festival suffered from too much Brooklyn. Even if the films aren't directly filmed in Brooklyn, many, many independent films originate in New York, which has two world-class film schools (NYU and Columbia), as well as a variety of major independent film organizations and festivals (the Independent Film Project, the Tribeca Film Institute, the New York Film Festival, BAM Cinemafest, New Directors/New Films, etc.).

There can also be advantages to studying in a smaller town, particularly as an undergraduate. As one example, the University of North Carolina School of the Arts has produced a vibrant community of independent film-makers, many of whom have had notable successes in recent years. Some examples include David Gordon Green (*Pineapple Express*, *George Washington*), Jeff Nichols (*Mud*, *Take Shelter*) and Aaron Katz (*Land Ho!*, *Cold Weather*). Studying in a smaller town can create a stronger bond than in big cities, where students often are spread out and form less cohesive units. When students from smaller towns move (often together) to Los Angeles or New York, they share a common culture and often remain lifelong collaborators and friends.

You should develop a little profile of the kind of films you love, and think about how they were made, by who, where and for how much money. Your taste will be your guide for many years to come, so it's important to have a clear understanding of how the films you love were actually made.

2. DID THE FILMMAKERS GO TO FILM SCHOOL?

After creating your little film biographies, you should have a stronger portrait of how some of your favorite films came into the world. The odds are that half of the filmmakers probably went to film school, while the other half worked their way up through industry jobs, jumped into filmmaking from another creative field, or are the form of space alien that came up with a brilliant film seemingly out of nowhere (this happens about once a decade, and is not really a career strategy). Many people also combine film school with professional experience.

Especially for crafts like editing or cinematography, people often work their way up through the hierarchy of crew positions, starting as an editing or

camera PA (production assistant) or intern, and slowly prove themselves up the chain through hard work, professionalism and acquired skill sets. The danger in this route is that you will learn a ton of technical skills, but lack the experience of making creative choices and mistakes from the driver's seat. Again, a primary benefit of film school is your ability to practice the craft of filmmaking, and if you are based in a city without a film industry, film school will give you the time, money and network to get started in a city that has one.

Now that you know a little more about the backgrounds of your favorite filmmakers, take them with a grain of salt. Every person's career is different, and you will need to develop your own profile of yourself, your interests and your goals. But knowing how it worked for other people never hurts.

3. WHAT COMPANIES MADE THE FILMS AND TV SHOWS I LOVE?

As part of your research into your favorite films, look at the companies that made them. Obviously all the major film studios are in Los Angeles, as well as a number of companies that produce for major independents like Wes Anderson.

Oftentimes with independent films you will see a company name like "The Movie's Title, LLC." This means that the producers founded a company specifically for the film. In this case, you can usually get a better feel for where a movie was made by looking at where the producer and director are based. Spend some time really tracking down the people you admire, and remember, people often make smaller movies outside of major film centers before they move there as well. There are a number of filmmakers who made films in Austin before they moved to Los Angeles, or who remain based in Austin but travel to LA to meet with the actors, producers and cinematographers who are based there. This form of travel can often be as expensive as living in an industry center, so remember, there's no free lunch in filmmaking.

Also keep in mind that the film industry is constantly changing. While the 2008 financial crisis killed a number of major New York–based independent film companies, the fact remains that, at the indie level, a lot of great content still comes from New York. Los Angeles and New York have fundamentally different histories, cultures and geographies that contribute to these differences.

For cinematographers, screenwriters and editors, most roads point to Los Angeles, which by virtue of its sheer size and wealth has a much larger network of opportunity than New York.

4. BIG CITIES/SMALL CITIES

At this point it should be clear that the center of power in the film industry is Los Angeles, with a small but influential base in New York. Most major American films and television, regardless of where they're filmed, have their origin in these two places. This is an extremely compelling argument to move to one of these cities, Los Angeles in particular. A major advantage of film school, again, is the opportunity to relocate to one of these cities and build your all-essential network there.

Another important point is that if you continue to move up as a filmmaker, you will inevitably need to travel to Los Angeles and New York to meet with producers, agents and other potential collaborators. Oftentimes the cost of commuting would make it equally affordable to just live in an industry center.

The advantage to not being based in New York or LA is that the cost of living is dramatically lower, as is the cost of filming. Austin, New Orleans and other smaller American cities have created vibrant local filmmaking communities. If you're interested in creating noncommercial, small, independent or experimental work, a small city can be a great place. The atmosphere is generally friendlier than in the big cities, where it seems that every private residence, parking lot or public park has been destroyed by a film crew at least once. Smaller cities can also be a great place to make your first films, and your first mistakes, and to build a network.

Living outside of an industry center, with discipline, should give you more time to work on your own creative projects, which will in turn help you develop your creative voice. Aside from your network, building your creative portfolio is the single most important thing you can do for your career. Your creative work will also be the best way to meet people, who will see you as a filmmaker as opposed to someone's assistant or intern.

5. READ THE TRADES

Like any industry, the film industry has a wave of media that cover its daily events. It's good to start getting acquainted with the major players and figures in the independent and studio sector. Here are some publications and sites (in alphabetical order) to get you started.

1. *American Cinematographer*

Required reading for cinematographers, this magazine features detailed interviews with working cinematographers on their art and craft.

2. *Deadline*

This is the leading free online publication for film industry news, focused in particular on the major Hollywood studios and television networks.

3. Film Crit Hulk

Film Crit Hulk is one of the best living critics out there right now (full disclosure, you already read him in the foreword). He writes extensive analyses of popular and art-house storytelling, with an emphasis on the storytelling and craft behind the films.

4. *Filmmaker Magazine*

Filmmaker Magazine gives an in-depth look at the life and craft of the independent filmmaker, including in-depth coverage of major festivals and films. There is no better way to get an idea of the daily obstacles working filmmakers overcome, as well as insight into their creative processes.

5. Indiewire

This is the go-to site for daily news on the independent/festival/art house film world.

6. The Daily Newspaper

As filmmakers, we are ultimately students of human nature. The daily news offers a tremendous portrait of the world, and endless inspiration for storytelling. World events shape the storytelling of our time; you need to know them and understand them. A local paper can also give you a particular insight into your own community that a national one cannot.

7. No Film School

This is an essential resource specifically designed for young filmmakers interested in learning the art, craft and technology of filmmaking. The site recently relaunched with an excellent new series of forums where filmmakers can answer questions for one another.

8. *Variety* and *The Hollywood Reporter*

The two staples of the Los Angeles film industry.

All this information can be overwhelming at first, but it's important to have a regular update on the events in the film world and the world at large. In

order to better interpret those events, and understand their origins, it's also important to know the history of the industry.

6. LEARN THE HISTORY

Cinema and television have a long and rich history, both inside the United States and internationally. Learning that history will be a valuable tool for you as a filmmaker and a human being. Here are some good books to get you started.

1. *The Big Screen: The Story of the Movies,* by David Thomson

This is one of the best single-volume histories of cinema and television out there. The book is particularly skilled at looking not just at movies but the growth and development of media in general.

2. *City of Nets: A Portrait of Hollywood in the 1940s,* by Otto Friedrich

The book that inspired the Coen Brothers' remarkable *Barton Fink*, this is an essential portrait of Hollywood's golden age.

3. *Easy Riders, Raging Bulls,* by Peter Biskind

An incredible look at the cinematic renaissance of the 1970s.

4. *The Mailroom: Hollywood History from the Bottom Up,* by David Rensin

An excellent look at the foundations of the modern studio system, with a particular focus on the agencies.

5. *Down and Dirty Pictures,* also by Peter Biskind

A trenchant analysis of the independent film boom of the 1990s.

6. *Sleepless in Hollywood: Tales from the New Abnormal in the Movie Business,* by Lynda Obst

The first third of this book is an excellent summary of the issues currently driving the Hollywood blockbuster machine. It looks at how international box office became the driving force behind current mainstream movie culture. The book devolves a bit into schmoozy war stories toward the middle,

but it's nonetheless an valuable analysis of the current situation driving Hollywood. If you choose to live in LA or go to film school there, you will get used to hearing, and perhaps eventually telling, a lot of war stories.

One thing to note is that each of the major creative eras in cinema were driven by both creative and economic factors. The 1940s and 1970s were driven by theatrical audiences, the 1990s were driven by home video and DVD sales, and our current era is driven by international box office. There is always an economic basis for the creative choices made in the film industry; it's important to understand them, as it will also help you define what kind of filmmaking career you aspire to.

7. WHAT KIND OF FILMMAKER DO I WANT TO BE?

All of this endless reading, research and history will ideally help you understand your particular interests, as well as what kind of filmmaker you would like to be. Tom Edgar and Karin Kelly's excellent if dated *Film School Confidential: The Insider's Guide to Film Schools* lays out three kinds of filmmakers: industry, independent and experimental. To those three it's important to add television, commercials and documentary as well. Let's look at each of them.

1. Industry

This very loose term refers to an elite group of filmmakers who make the studio blockbusters and major television shows. They're almost exclusively based in Los Angeles and are very well compensated for their work, which is very expensive to make and therefore has to reach massive audiences in order to recoup its cost. The power structures center around the studios, major production companies, talent agencies and management companies, all of which constantly scour the country and world for new talent. Los Angeles is where major blockbusters and most major television shows originate, as it is the only place in America that has both the talent and money to make them happen. The line between features and television have increasingly blurred, with creative talent increasingly migrating between the two.

2. Independent

This is the tradition of Sundance, Cassavetes, Miramax and all the scrappy young filmmakers out there. The power and attention are often centered on a handful of major festivals (Cannes, Toronto, Venice, Berlin, etc.). The indie circuit is one major feeding ground for studio talent, and is probably

the closest thing Hollywood has to a minor league. Not all indie filmmakers are interested in traditional Hollywood careers (nor is Hollywood interested in them), and most indie filmmakers teach, consult, apply for grants, shoot commercials and corporate videos, and do various odd jobs to help pay for their lives and films, which are often inseparable.

3. Documentary

The documentary and independent world are very closely linked, but there are some key differences. It's important to know that if your passion is truly documentary film, there are schools that specialize specifically in that field. Oftentimes documentary can become the neglected sibling of fiction production at major film schools, so it's important to research the specific documentary programs of the schools you're interested in as well.

There is a large and vibrant documentary community, including broadcasters, specialized festivals, institutions and awards. If this is your passion, take time to familiarize yourself with them. The International Documentary Association (IDA) publishes an essential quarterly magazine that is a great resource to immerse yourself further in this world.

4. Experimental

Often at the cutting edge of cinema, experimental film is treated more as a fine art than traditional narrative films. Though present at festivals, these filmmakers often operate more within the fine art and university systems than the traditional film industry.

5. Commercial

The commercial film world, like documentary, overlaps with fiction, but is also a separate entity. There are few schools that offer comprehensive programs in commercial filmmaking, and many filmmakers that get into it do so by shooting specs (as in speculative, or unpaid) commercials or music videos. Although there are few specialized programs, all of the same principles of directing and cinematography apply to commercial filmmaking as well. A film school training could be an excellent prerequisite to this world. Know that if your main interest is in commercial filmmaking, you need to go after this quickly: find internships at production companies and ad agencies that produce commercials, and focus on building a portfolio that includes commercial work. It is just as difficult to have a successful career in this world as any other one, and the earlier you can specialize the better.

6. Television

As it undergoes its current renaissance, television has become an increasingly important part of film school education. As a screenwriting student interested in television, make sure to find a program that offers extensive writing courses in TV. Again, a school in Los Angeles or New York, where most American television is made, is ideal, because you can begin the long process of going from intern to production assistant to, hopefully, writer's assistant to writer.

Obviously there is much overlap between all of these specializations: fiction directors shoot commercials and documentaries, screenwriters write a successful feature then transition into television, and so on. These worlds are also somewhat separate, though, and when choosing a school, companies to intern at, and what kind of films you want to make, it's important to keep these tracks in mind. The people who cross over from one world to another generally have a sizeable success in their chosen specialty, such as an indie filmmaker who wins at Sundance then does a major commercial. The reality is that it's extremely difficult to be successful in any one of these fields, so the more and earlier you can specialize, the more appropriate your experience will be to your ambitions.

Sidebar: Choose the Major You Actually Want to Pursue

Knowing others is intelligence; knowing yourself is true wisdom.
Lao Tzu

A cautionary tale. A dear friend grew up always wanting to direct documentaries, but she was scared of the risks that life might entail. She also had very little experience directing documentaries, which she felt was a prerequisite to applying to film school (it wasn't). So she decided to apply to a graduate producing major at a major film school, just to be safe. She assumed that when she got to school, she'd be able to take all the directing classes she wanted to, and could basically sneak into the program that way, without having to admit that she wanted to direct.

She was very surprised to learn that as a producing student, her access to equipment and directing classes was very limited. She has since made some successful documentary films, but she counts much of her time as a producing student, in a program that emphasized Hollywood producing, as wasted, when she could have been focusing on her craft as a documentary filmmaker.

The point of the story is this: You are applying to film school, which is an inherently risky choice. No matter what major you choose, this will never be as responsible as going to medical school, law school, accounting school or dental school. If you go to film school, go for the major you really want to pursue. No one gets brownie points for choosing a "safe major." There are no "safe majors" in film school.

The second important lesson is that your previous experience does not determine which major you should choose; you do. If you did your undergraduate degree in creative writing, that does not require you to be a screenwriter. Many schools require a reel or writing sample to apply, but these are not impossible obstacles to overcome. See them as an opportunity to finally dive into the experience of making things, which is why you're applying to film school to begin with.

Applying to Film School: Program-Specific Research

1. EIGHT GREAT AMERICAN FILM SCHOOLS (AND SEVENTEEN VERY GOOD ONES)

The American film industry is centered in Los Angeles and New York, which also host nearly all of the elite American film schools. Understand that film schools differ not only as broad institutions, but in their individual programs and the kind of filmmakers they produce.

Here it's helpful to create a portrait of yourself: your ambitions, taste, needs, finances, learning style and maturity. Take stock of your past experiences: Do you feel ready to make a leap to a big city? Are you the kind of person who enjoys formal learning? Would you benefit from some more life experience before you lock down a school you want to attend? How are your grades? What major are you interested in? Which schools are known for it?

There's an old adage that every time a door opens in the film industry, the person who enters that door closes it behind them forever. You will have to create your own path, which may or may not involve one of the top film schools. That being said, life is short, and, for all of the reasons mentioned at the beginning of this book, film school can be a tremendous accelerator for many people on their path to filmmaking.

But film school is not a golden ticket to an exciting career. What film school provides is access to a series of opportunities that, combined with a ton of hard work, can slowly gestate into a career in film.

With all that in mind, here are eight great film schools that have a solid reputation for producing top-level filmmakers. Included as well are eighteen more schools that have solid reputations and are deserving of note.

Ranking something as unique and idiosyncratic as an education is absurd, so these schools are listed alphabetically. Please note as well that I've only included the degree programs that fit into this book's core disciplines (narrative and documentary directing, screenwriting, producing, editing and cinematography).

It is absolutely necessary for you to do your own research. Every individual is different, as is every film school. The point of this book is not to tell you which film school to go to, but to help you know yourself and the film school process better, so you can then see which film school might fit for you. Appendix B's. "Film School Budgeting Worksheet" provides a form that can help you as you continue your own research.

On a final note, the prices listed here are the "sticker price" for attendance. Many schools have generous grant and scholarship programs, so you are encouraged to look into those to help get a realistic sense of what film school will actually cost.

1. American Film Institute Conservatory (AFI)

AFI is perhaps the most prototypical example of an industry school. It's the only one that offers both editing and production design as majors, and it expects all students to work together on each project. It accepts only graduate students, who are expected to have a strong level of industry knowledge before entering the program, which at only two years, goes by in a blur. Recently, AFI has been especially renowned for its cinematography program, which produced Janusz Kaminski, Steven Spielberg's cinematographer. But don't let that industry word fool you; notable directing alumni include recent Palme d'Or winner Terrence Malick, as well as Darren Aronofsky.

2014 Tuition: $42,591 first year; $51,809 second year

Degrees Offered: MFAs in Cinematography, Directing, Editing, Producing and Screenwriting

2. California Institute of Arts (CalArts)

None other than Walt Disney was the founder of CalArts, situated in Valencia, California, about an hour's drive north of Los Angeles. Aside from its world-renowned animation programs, CalArts also offers programs in narrative film directing, as well as experimental film. This is perhaps the "artiest" of the top film schools, but it boasts a solid record of achievement in the traditional narrative world as well. Director James Mangold, famous for films like *Walk the Line*, *3:10 to Yuma*, and *The Wolverine,* is just one of CalArts' many successful alumni.

2014 Tuition: MFA $41,700

Degrees Offered: MFA in Film Directing

3. Columbia University

How is an Ivy-league school to distinguish itself among so many strong competitors? If you ask around, one thing sets Columbia apart: a relentless focus on story. This program is the only one of its kind to offer a major in

Screenwriting/Directing, which already says something about its auteur and indie sensibilities. Aside from its continual student and alumni presence at top festivals like Sundance, Columbia has also recently distinguished itself for its remarkable female directors, including Nicole Holofcener, Kimberly Peirce and Jennifer Lee, the writer and co-director of *Frozen*, the highest-grossing film ever directed by a woman.

2014 Tuition: MFA $53,484 first two years; $4,420 third year

Degrees Offered: MFA in Screenwriting/Directing, MFA in Creative Producing

4. New York University (NYU)

The king of the New York schools, a complete list of NYU's successful alumni would probably be longer than this book. The school is situated in Greenwich Village, in the heart of New York City, which, despite some blows from the recent economic crisis, is still the center of American independent film. Some successful alumni include older powerhouses like Martin Scorsese and Joel Coen, to more recent alumni like the filmmakers behind the 2014 SXSW Jury Prize Winner *Fort Tilden*, and television heavyweights like Vince Gilligan, the creator as well as showrunner of *Breaking Bad*.

2014–2015 Tuition: Undergraduate $48,272; Graduate $50,186 (Program Cost)

Degrees Offered: BFA in Film and Television, MFA in Filmmaking, MBA/MFA Dual Degree in Producing, MFA in Dramatic Writing

5. University of California, Los Angeles (UCLA)

Located in the heart of Westwood, in West Los Angeles, UCLA's list of accomplishments is on par with any of the other major schools, with one major difference: as the only public school in the top five for many students, UCLA's tuition is less than half of its fellow titans. Competition is especially rigorous to get into its undergraduate programs, which recently began allowing freshmen applicants after decades of only allowing students to enter in their junior year. Famous alumni include Francis Ford Coppola, Alexander Payne, Justin Lin and David Koepp.

2014 Tuition: Undergraduate $14,966 to $15,131 ($37,844 to $38,009 out-of-state); Graduate $15,582 to $25,196 ($30,684 to $37,441 out-of-state)

Degrees Offered: BAs in Film, Television and Digital Media, including specializations in Cinematography, Producing, Production/Directing

(Narrative or Documentary) and Screenwriting; MFAs in Film, Television and Digital Media, including specializations in Cinematography, Producing, Production/Directing and Screenwriting

6. University of North Carolina School of the Arts

UNC's School of the Arts is one of America's only major film programs geared entirely toward undergraduate students. Students tend to form a tight bond before they move to larger filmmaking centers, bonds which often last a lifetime. The school has produced a tight-knit circle of successful studio and independent filmmakers, that begins with David Gordon Green (*Pineapple Express, Prince Avalanche, George Washington*) and now counts filmmakers like Jeff Nichols (*Mud, Take Shelter*) and Aaron Katz (*Land Ho!, Cold Weather*) among the ranks of its successful alumni.

2014 Tuition: Undergraduate $8,363 ($23,847 out-of-state)

Degrees Offered: BFA in Filmmaking, with concentrations in Cinematography, Directing, Editing and Sound, Producing and Screenwriting

7. University of Southern California (USC)

Founded in 1929, USC is the world's oldest and most famous film school. With elaborate, high-tech facilities, and based in the heart of America's film industry, USC is a cinematic powerhouse. While known primarily as an industry school, USC boasts successes across all spectrums of the film industry, including Ryan Coogler, whose *Fruitvale Station* won the Grand Jury Prize at Sundance in 2013. More established alumni include George Lucas, Judd Apatow and Ron Howard.

2014 Tuition: Undergraduate $47,562; Graduate $74,976 to $88,608

Degrees Offered: BAs in Film and Television Production, Writing for Screen and Television, Interactive; MFAs in Film and Television Production, Writing for Screen and Television, and Producing (Peter Stark Producing Program)

8. University of Texas at Austin

Located in America's third film capital, UT Austin has a lot to celebrate: in 2014 one of its students won the Cannes Cinéfondation competition, the highest honor for a student film, while alumni Matthew McConaughey also won his first acting Oscar. Set in indie darling Austin, home of major film

festivals like South by Southwest (SXSW) and Fantastic Fest, as well as indie exhibition/distributor Alamo Drafthouse, UT Austin is also the only non-California public university with a "Semester in LA" program.

2014 Tuition: Undergraduate $9,664 ($34,216 out-of-state); Graduate $9,056 to $10,833 ($17,048 to $20,598 out-of-state)

Degrees Offered: BS in Radio, Television and Film, MFAs in Production and Screenwriting

9. Seventeen More Very Good Film Schools

These are all very solid film programs, once again listed alphabetically.

1. Boston University

2014 Tuition: Graduate $46,422

Degrees Offered: MFA in Film Production, MS in Television, MFA with a Concentration in Screenwriting

2. California State University, Northridge

2014 Tuition: Undergraduate $6,542; Graduate $7,786 (in-state; non-California residents add $372.00 to tuition for each unit)

Degrees Offered: BAs in Film Production, Screenwriting, and Media Production; MFA in Screenwriting

3. Chapman University

2014 Tuition: Undergraduate $44,710; Graduate $35,960 to $42,840

Degrees Offered: BFAs in Creative Producing, Film Production, News and Documentary, Television Writing and Production, BA in Screenwriting; MFAs in Film Production, Film and Television Producing, Documentary Film, Screenwriting; JD/MFA in Film and Television Producing; MBA/MFA Film and Television Producing

4. Colorado Film School

2014 Tuition: $3,800 (in-state), $5,400 (residents of western states), $15,000 (nonresident)

Degrees Offered: AAS in Writing and Directing, Writing and Producing, Post Production, Cinematography and Screenwriting

5. Columbia College Chicago

2014 Tuition: Undergraduate $22,884; Graduate $1,077 per credit

Degrees Offered: BFA in Cinema Art and Science (various concentrations), MFAs in Cinema Directing and Creative Producing

6. DePaul University

2014 Tuition: Undergraduate $33,390; Graduate $18,840

Degrees Offered: BA in Digital Cinema, BS in Digital Cinema, MFAs in Cinema and Screenwriting

7. Emerson College

2014 Tuition: Undergraduate $36,650; Graduate $1,145 per credit

Degrees Offered: BA in Production, BFA in Media Arts Production, MFA in Media Art

8. Florida State University

2014 Tuition: Undergraduate $7,544 ($25,959 out-of-state; varies slightly year to year); Graduate $21,569 ($49,982 out-of-state)

Degrees Offered: BFAs in Motion Picture Arts and Production; MFAs in Production and Writing

9. Harvard University

2014 Tuition: Undergraduate $43,938; Graduate $40,416 (first two years)

Degrees Offered: BA in Visual and Environmental Studies: Film/Video Production, PhDs in Film and Visual Studies, and Anthropology: Media Anthropology

10. Loyola Marymount University

2014 Tuition: Undergraduate $40,680; Graduate $1,086 per unit

Degrees Offered: BAs in Film Production and Screenwriting; MFAs in Film and TV Production, Writing and Producing for TV and Screenwriting

11. Northwestern University

2014 Tuition: Undergraduate $46,836; Graduate $36,900

Degrees Offered: BA in Radio/Television/Film, MFAs in Documentary Media and Writing for the Screen and Stage

12. Rhode Island School of Design

2014 Tuition: $44,284

Degrees Offered: BFA in Film/Animation/Video

13. Ringling College of Art and Design

2014 Tuition: $36,880

Degrees Offered: BFA in Digital Filmmaking

14. San Francisco State University

2014 Tuition: Undergraduate $6,468 ($18,372 out-of-state); Graduate $7,734 to $19,368

Degrees Offered: BFAs in Filmmaking and Screenwriting, MFA in Cinema

15. Savannah College of Art and Design

2014 Tuition: Undergraduate $33,795; Graduate $34,605

Degrees Offered: BFA in Film and Television, MFA in Film and Television

16. Stanford University

2014 Tuition: $42,690

Degrees Offered: MFA in Documentary Film and Video

17. Syracuse University

2014 Tuition: Undergraduate $40,380; Graduate $24,138

Degrees Offered: BA and MFA in Television, Radio and Film, MFA in Documentary Film and History

2. THE POSSIBLE MAJORS REVISITED

The five most common production-oriented film school majors are:

1. Cinematography—the author of the images.
2. Directing—the creative author of the overall film.

3. Editing—the author of the editing.
4. Producing—the creative CEO of the film.
5. Screenwriting—the author of the screenplay.

Each of these majors has a strong creative component, and all are shaped through intense collaboration with the other disciplines.

It's important to choose the proper focus, especially for graduate film school. Again, due to the nature of graduate film school, people generally stay within the curriculum of their own programs.

Film schools are relentlessly expensive and complicated to run, so resources are always being diverted to the specific programs and the students within them. All this is another way of saying that you choose the major you actually want to do, and that there is no "sneaking into a program through a different major," as some people try to do.

In order to help you with your decision, read as much as you can about each of the separate fields. Most people want to be a director by default; it is the most visible and best known of the majors. However, all successful directors get to where they are through creative collaborations with the four other roles. Take time to explore them. If your intuition leads you toward editing, embrace it. If you truly know what you want to do before you go to film school, you will be miles ahead of the competition.

3. WHAT DOES EACH SCHOOL'S PROGRAM LOOK LIKE?

Here are some basic questions you can ask to help get a picture of each school's individual program:

1. How many students are in an incoming class?
2. How many years is the program?
3. What experience level do students have coming in?
4. What does the first year of the program look like? The second, third?
5. How much is tuition?
6. What are some of the faculty's accomplishments?
7. What kind of films do the alumni make?
8. What kind of financial support are students offered?
9. What do graduates of the program say?
10. What kind of internships does the school offer?
11. What are the school's recent alumni doing?

12. Where is the school located? Are there industry opportunities there?
13. If the school is not based in an industry center, do they have opportunities for students to travel and intern there?

4. HOW MUCH DO THEY COST?

This is the nail-biting moment of the process: yes, film schools are really expensive. Perhaps most terrifying is that the sticker prices can change, though they seem to have remained relatively stable over the last few years.

Producing, screenwriting and editing students have the major financial advantages of shorter programs and not having to finance student films, which can cost significant sums of money. They can thus be far more affordable than the extended graduate directing programs, where students not only spend more time enrolled but often finance their own films. In spite of the costs, however, if you want to direct, there is generally no substitute for directing experience. Although there are many examples of students making the transition from one discipline to another, it's always best to start in the discipline that you're most passionate about.

The reality is that at least in graduate film school, most people pay for school with significant student loans. In spite of this there are several ways of reducing the cost of attendance. Before we get into that, it's important to estimate what that cost of attendance will be. As mentioned, for screenwriting, producing and editing students, this calculation is far more straightforward than for directing students: simply look at the tuition for the number of years you'll be enrolled, then add your living expenses.

For graduate directing students, the two most important factors to look at while budgeting a film school education is how many years you will be fully enrolled (i.e. paying full tuition), and how much financial support (if any) a school offers for your student films.

Graduate film programs understand how expensive they are. In order to help with this cost, at some schools, in addition to many generous scholarships, they often have extremely reduced tuition for directing students while they make thesis films. Thus, while you may be at film school for four to five years, you will only be paying full tuition for two to three of those years. This is what you must look at to determine the real cost of film school.

The second most significant cost, for graduate and undergraduate directing students alike, is their films. To this end it is very important to see

whether the school offers financial support for student films, and if so how much. Some schools will only offer financial support for a handful of filmmakers, while others offer the same level of financial support for all students.

While choosing your program, it's important to budget out *every potential cost you may face*, including living expenses, automotive, health insurance and contingencies.

Another important reality is to remember that you generally cannot expect to know the exact amount of financial help, if any, you will receive in film school. When budgeting, it's good to look at the worst case scenario. That way, any extra help that comes along the way (and it usually does) will seem like a blessing, not an entitlement.

To this end, it is also wise to plan for a 5 percent tuition increase each year. If it turns out to be less than that, well then that's money you've saved.

5. CAN I AFFORD IT?

Unless your current job consists of managing your family's money, or perhaps "investing" it, you probably can't afford film school in the barest sense.

This is the moment where everyone curses fate for not being born rich. The wealthy have many advantages, to be sure. However, family wealth can be a hindrance as much as an advantage. Money can remove the stakes from people's personal decisions, allowing them to exist in a form of limbo where they never have to lay anything on the line. Major cities are filled with wealthy dilettantes, who constantly discuss the novel they have in progress, or the screenplay they would make if only the right circumstances came. Other times they finance their own disastrous projects, unable to face the reality of their own weaknesses.

For the rest of us, it's very important to understand the consequences of living in debt. A second hard truth: entry level jobs in the film industry do not pay well, if at all. Unfortunately many of the best opportunities go to those who don't need to work for money. Film Crit Hulk, in his excellent essay on Film School (see the resources section of this book), discusses this dynamic of privilege very eloquently:

> PLEASE UNDERSTAND THAT THE FOLLOWING STATEMENT IS PURELY AN ANECDOTAL ESTIMATION BASED ON YEARS OF BEING IN THIS BUSINESS, BUT HULK SURMISES THAT

THOSE WHO HAVE HELP FROM THEIR PARENTS GENERALLY
HAVE A CAREER THAT ACCELERATES ABOUT 3–4 YEARS
FASTER THAN THOSE WHO DO NOT AND A MUCH BETTER
CHANCE AT GETTING A "BREAK." SO IF YOU ARE ON THE
SIDE OF DISADVANTAGE, KNOW THAT YOU'RE GOING UP
AGAINST A SYSTEM THAT IS GOING TO PUNISH YOU FOR IT.
BUT YOU CAN'T LASH OUT. YOU CAN'T RUE THE DAY. YOU
SIMPLY HAVE TO TRANSCEND IT. AND IF YOU DO HAVE
SOME ADVANTAGES WITH MONEY, THAT'S FINE TOO. WORK
HARD AND PROVE YOURSELF. JUST BE INCREDIBLY
THANKFUL AT THE GOOD FORTUNE. THAT'S ALL ONE CAN
EVER ASK.

All of this talk of privilege aside, the most important thing to understand is that entering film school, and the debt that this entails, will dramatically impact the rest of your life. Living with a high debt level will affect nearly all of your major life decisions, from buying a house to having kids.

This might all sound a little grim, but again, it's important to have a realistic perspective on what the risks are. If you're feeling a lot of doubt, go back to the section on the merits of film school and see whether they reassure you. The essential Faustian bargain of film school is time, relocation, experience, portfolio and network versus debt.

It's a difficult reality, but as mentioned, there are many things you can do to alleviate your debt level, and know that you're not alone; student loan debt is fast becoming one of the universal burdens of our generation. At least there weren't any wars, right? (Joking.)

6. CAN I GET IN?

Film schools are notoriously vague about what they are looking for in potential applicants. This is in part because of the collaborative nature of film school: each school looks for a group of students that can work together in high-stress situations to create each other's films, critique each other's screenplays and give feedback on producer's pitches. Thus when you apply to film school, you are not only being screened as an individual applicant, but for how well you will fit into a cohort of filmmakers you've never met.

As an undergraduate applicant, grades and extracurricular activities are important, because they are often your only real life experience. If you don't have stellar grades but are still above a 3.0 (usually a benchmark for top

schools), perhaps you can build some compelling practical experience that you can draw on in your written materials.

I only realized that film school even existed after I completed my bachelor's degree at Kalamazoo College in southwest Michigan. My GPA was good but not great (around a 3.2). I did have a love of the German language, and in my senior year received a Fulbright Scholarship to move to Germany for a year. Afterwards I moved to Berlin and worked for a variety of production companies. Combined with my GPA and essays, this was enough experience to get me an interview at UCLA.

All this is to say that if you weren't a stellar student in high school or undergrad, you can make up for these things through the experience you shape for yourself and how you express yourself through your written materials. If you're looking at undergrad film school and your grades are too low, consider doing a degree in another field, get your grades up, then apply to graduate school. Any career/life experience you can bring to film school will undoubtedly help you while you're in it.

7. PICK THREE TO FIVE SCHOOLS

As you do your research on the film industry itself and each of the individual schools, you will start to get a feeling for a handful that might be right for you. Try to whittle your list down to a reasonable number, say three to five schools. With a small number of applications, you can be sure that you'll put the majority of your effort into the schools you really want to go to. You'll also make sure to invest your time and effort in making those the highest quality applications. If you only apply to the schools you really want to attend, then hopefully your passion for those schools will show in your application.

There will always be schools that seem fascinating but might not be quite the right fit. Have no regrets. By committing to a course of action you make it infinitely more likely to come true.

> **Sidebar: If You Don't Move to a Big City**
>
> One of the big opportunities that film school offers is the time, finances and motivation to relocate to an industry center, where you can meet potential collaborators, gain your first experience and be surrounded by people who share your passion.

The industry centers are, however, very expensive. While rents in Los Angeles are slightly cheaper than in New York, the basic requirement of a car more than levels out the difference in expense, as does the time spent cursing the gods while stuck in traffic. Those are unfortunately the prices you pay for your passion, and they will not change any time soon.

If you do not choose to attend film school in an industry center, you should take some time to consider what you will do upon graduation. There are two options, which I will explore here.

1. Leave

Perhaps you know that you do want to move to Los Angeles, but don't yet have the money, experience or gumption to do so. Perhaps you're 18 and the opportunity to live rent-free with your parents for a while longer is just too tempting. You know you want to move to LA, but you'd rather do it after undergrad. Or maybe you can't get into one of the top film schools but are still set on a life in filmmaking. The best thing you can do here is gain all the experience you can at the lowest cost possible, all while saving a substantial sum of money and building a network of passionate friends and collaborators that you can move to Los Angeles with after graduation. You should also save several thousand dollars to cover living expenses, car, food, student loan payments, and more while you find your feet in the city. Moving with a group of friends will give you an essential social and professional support network while you make the massive adjustment to life in LA.

2. Stay

Every year at the South by Southwest Film Festival in Austin, Texas, there is a filmmaker lunch. At this lunch all the filmmakers from the festival meet the other filmmakers from their sections, get a little drunk and mingle. The lunch is held at Troublemaker Studios, which is owned by Robert Rodriguez, director of *From Dusk Till Dawn*, *Spy Kids*, and *Sin City*, among many others. At the beginning of the brunch Rodriguez gives a speech about how when he started out, Austin was not a film town. Through his efforts, and the efforts of fellow filmmakers and friends like Richard Linklater, Austin blossomed into the third capital of the American film industry.

This would be an ideal outcome of staying in your community. If you're committed to making small local films on a low budget, perhaps you don't need to move to Los Angeles or New York. What you need in

that case is a lot of willpower and a network of friends who are willing to help each other get their films made. Take that same group of friends you would move to LA with and start a writers group; make each other commit to making small films in your town. Build your own infrastructure. Help each other. Maybe one of the films will be successful and lead to other things, maybe not. At least you will be making films. So many people move to Los Angeles with the dream of making films, only to end up as an assistant on other people's films, too broke and exhausted to make their own.

If you decide not to move to a filmmaking capital, you will need to become your own film industry. Live cheaply and make as many films as you can. Independent cinema was created by people with a do-it-yourself spirit who decided that making films was all they wanted to do. At various points people like this have changed the history of cinema.

Chapter | four

Apply

At this point you should have given some thought to what kind of filmmaker you want to be, where in the country you might want to go to school, and chosen your three to five schools that you feel would work best for you. Hopefully the deadlines for the applications aren't in two weeks. If they are, maybe it's worth taking another year to work on your applications, develop some life experience, and make sure you put your best foot forward.

1. START EARLY

As a filmmaker, you will constantly have to schedule for and meet deadlines, often for no pay. Your film school applications are thus a perfect opportunity to train your discipline muscle, which you will need for the rest of your life. It is not an easy thing to sit down at your desk and write a screenplay, or email someone you respect to ask for help. The sooner you learn the discipline, courage and perseverance to do these things, the better off you will be.

Give yourself at least six weeks before the deadlines, which are usually in the late fall, to research schools, decide which ones you want to apply to, and assemble all the requisite materials. If you are required to make a film as part of your application, give yourself *a minimum of two months more*, for a total of three and a half months before the deadline. Learn to ask for recommendation letters early, and you will be more likely to receive them. Also don't be afraid to follow up with professors if you don't hear back from them; polite persistence will be your best ally here.

If you take the time to get feedback on your essays and creative materials and then revise, they will be more likely to help you actually get in.

2. MAKE AN APPLICATION TO DO LIST AND MATCHING CALENDAR

This is a habit you will have to develop now. Any major task, like applying to film school, can be broken down into smaller tasks, like outlining your statement of purpose, or emailing a professor to ask for a recommendation letter.

The best way to go about doing this is to work backwards from the deadline you want to hit. For all my project management, I use a combination of a productivity or "To Do" list program and a calendar.

If you're applying to the graduate screenwriting program at AFI (application deadline December 1), and you want to submit a week early to allow

for any contingencies (late recommendation letters, application lost in the mail, etc.), then you would create a new To Do list.

Fill in all of the elements of the application you need to submit. Here is a sample list of everything you need to do to apply:

☐ **AFI Film School Application**
 Tags
 Due Date
 Notes

☐ Complete Online Application
☐ Pay Fee
☐ Narrative Statement
☐ Resume
☐ Recommendation Letter #1
☐ Recommendation Letter #2
☐ Transcripts
☐ Submission Agreement
☐ Screenplay Sample (Up to 20 Pages)

Figure 4.1

That's a lot of stuff, right?

I counted nine basic steps to submit a full application (depending on how many recommendation letters you send). If you add another two to four schools to that equation, that's a lot of work!

It's essential to break applications down into separate action steps. This helps psychologically—it's much easier to "pay a fee" than to "apply to film school"—and also in terms of efficiency: you can see which things need to be done now and which can be done later.

Now that you have your list of tasks, you can analyze each task and proceed to break them into even smaller tasks, ones you can actually complete. "Recommendation Letter #1" isn't something you can actually do. So perhaps that needs to change to "make a list of who could write recommendation letters." Then "email professor Turner to ask for a recommendation." Professors get a lot of requests for recommendation letters, and they are often out of the country on sabbaticals or for other reasons. It's important to

reach out to them early in the process so they have time to write something good. Also remember that they often receive several of these requests, so it's helpful to politely remind them after an appropriate amount of time if you haven't heard from them.

The Narrative Statement task is also a bit broad right now. Perhaps we could break that down into "Outline Narrative Statement," "Write 1st Draft of Narrative Statement," "Send 1st Draft for Feedback," "Rewrite Narrative Statement," and "Polish Narrative Statement."

As you do more of this, it becomes less necessary to be so specific with each task, but it never hurts. When you finish a difficult project, make sure to reward yourself with something small: positive reinforcement is a powerful thing.

So now that we have our To Do list, look at your calendar. Now is the time to schedule all of the things you need to do in it. Go through and work backwards from when you need to send your completed application, filling in every little task you gave yourself for the project. Make sure to give a realistic amount of time to order official transcripts, as well as to solicit feedback on essays, get recommendation letters and revise your materials. You'll need to complete the same process for each of the schools you're applying to.

It's that simple: look at all the requirements in early September, make a To Do list for each application, schedule those To Dos in a calendar, then actually do them.

3. WRITE YOUR STATEMENT OF PURPOSE (PERSONAL STATEMENT)

Most schools require the equivalent of a statement of purpose (also known as a narrative statement, personal statement, etc.), which outlines why you'd like to become a filmmaker. This is often the most important document in your file, and therefore deserves a massive amount of time and attention. As an aspiring filmmaker with little practical experience, this is also often the only window a school has into your experiences, values, taste, background and personality. The answers to this question are, and should be, as diverse as the applicants writing them.

So what are schools actually looking for? One professor at a top school who reads hundreds of these applications a year puts it very simply: The schools are looking for an interesting human being. Someone they'd like to work with, someone they'd like to teach, someone who's both teachable and

curious about the world. A question professors ask themselves a lot while reading these essays is: "Is this someone I'd like to have in my class?"

Here are some additional questions which can help you outline your statement of purpose:

1. What is your earliest memory of film?
2. What made you want to be a filmmaker?
3. What makes you, as a human being, unique?
4. What makes your life experience unique?
5. How can you connect that experience to creating film?
6. Why are you drawn to the specific discipline (screenwriting, editing, etc.) that you're applying to?
7. What do you think cinema is? and can do?
8. Why did you choose this particular school?
9. How are you and that school a good fit?
10. What do you hope to gain from your time in film school?
11. What can you contribute to a film school environment?

Through your statement of purpose a school will ideally get a compact and rich portrait of your life experience, writing style and relationship to filmmaking. It's a tall order, which is why you need to take some time to get it right. I revised my statement of purpose for weeks, including several rounds of feedback from trusted friends, before I submitted my application to UCLA.

On a final note, professors have commented that they read far, far too many personal statements where it feels as if applicants are writing them off the top of their head. One professor went so far as to say that "If the letter feels like something you wrote in 20 minutes, that's the kiss of death." If you don't take the time to make an articulate and carefully reasoned case for why you should be accepted to a school, who will?

4. ASSEMBLE YOUR WORK SAMPLES

Depending on what major you apply to, most schools will ask you for either a treatment for an original story, a screenplay, visual materials, or all of the above. In doing so, focus on quality over quantity. If you've made three short films, and one of them is significantly better than the other two (as often happens), include the strongest scenes from your strongest film, or only the strongest scenes from all three. If you haven't made a festival-quality film yet, and even if you have, brevity is king.

For screenwriting and other disciplines that require written materials, you should follow the same principle. One outstanding short story or screenplay will speak far more for you than 15 mediocre ones. Remember that top film schools receive hundreds, if not thousands, of applications, and that professors are always overworked when it comes to admissions. Make sure to put your best foot forward. This means careful proofreading of written materials as well: sloppy, typo-ridden writing is another surefire deal breaker.

Some further basic pointers in assembling a visual reel:

- Brevity and quality are more important than quantity.
- An interesting story is better than pretty pictures.
- Choose five minutes of your best material. The people watching them will be grateful. Just because a school says it allows up to a half hour of material does not mean you should take it up on its offer.
- Keep titles simple.
- Make a DVD that plays directly when you put it in.
- Make it as easy as possible to watch and enjoy your DVD.
- No special features. No one cares.
- Test the DVD on a number of players.
- For schools that provide a link to upload your sample, a simple title with your name, program and the length of the sample will suffice.
- People are impressed by what is on the reel, not what is around it, such as packaging or elaborate photos of yourself.
- Show your reel to friends who aren't going to lie about how bad something is.
- In a similar vein, if your intuition tells you something is bad, cut it. Brevity.

5. REVISE YOUR APPLICATION BASED ON FEEDBACK

Hopefully at this point in your life you have a few honest people you can trust. Perhaps it's a professor, friend, relative or someone in the industry. Now is the time to politely ask for feedback on your film school applications. Favor the people you're afraid of, the ones you know will be honest with you.

After you get their feedback, which will probably be a mix of praise and things you need to improve on, take a day off to give yourself some distance. Go back and reread the feedback, trying to discern notes that you both

agree with and can implement. Be brutal with yourself. This is the same process you will go through with all of your creative work.

Continue this process, revising as necessary, until you feel that you have the highest quality application possible. If you submit your best possible work, then you should be proud regardless of whether you're accepted. At least you're giving yourself the best possible chance.

6. POLISH (READ IT OUT LOUD)

After you incorporate a few rounds of feedback (how many depends on each individual), you will approach the final version of your materials and enter the polishing phase.

Polishing your materials consists of eliminating all spelling and grammar errors, as well as making sure that each sentence and word is the exact one you want to choose. Yes, this is difficult and tedious. Yes, it is very important. The last reason you want to appear unprofessional or unqualified is because of something as simple and fixable as spelling or grammar.

At this moment it can be a huge help to read your materials out loud. The act of reading something out loud forces us to slow down, enter the mind of the reader, and focus on the minutiae of the writing. There is no better way to finalize a piece of writing.

Continue this process, revising as necessary, until you can read each piece through with minimal hesitation. Now you're ready to send your application.

7. SUBMIT

Now that you've finally assembled all your materials, both online and off, you're ready to click "send" and mail your final physical application. If you're submitting the week before the deadline, you won't have to stress about whether your application will get there on time, or waste money on a courier.

If you've put in your full effort and met your deadline, be sure to reward yourself. It's not an easy thing to complete all of those applications, especially with time to spare. Take a moment to get yourself some little thing you've always wanted, or just take the afternoon off and revel in your achievement. It's important to reward ourselves for good behavior; it makes us more likely to repeat it in the future.

If you didn't get all the materials in on time, or you had to scramble at the last minute and are now exhausted, take a moment to reflect on why that is. What did you do wrong? Did you miscalculate how long something would take? Was it hard for you to motivate yourself to actually write the application?

These talkdown sessions are an essential part of the creative process, one you will hopefully encounter many times in film school. You need to understand your own strengths and weaknesses when it comes to hitting deadlines, a crucial skill for creative people. The film industry is brutal and unforgiving with deadlines because of the massive competition for every imaginable opportunity. If you get in the habit of setting and hitting deadlines now, you will have a solid leg up on that formidable competition.

A final note: In my teaching, I often see a form of neurosis in my students I call "I didn't really try syndrome." You've probably met someone like this, who spends life brushing off failure with the phrase "I didn't really try."

In order to succeed in life you have to work very hard, be organized and do your best, because that's the only way anyone actually succeeds. Don't allow yourself the excuse of "I didn't get in to film school because I applied last minute," or "I didn't get in because I didn't really try." This is at best disorganization and at worst sheer cowardice.

If you do your best and you're not accepted, then you know you need to work harder and reapply, or try something else. Remember, this is film school; no sane person will recommend that you go, present company excluded. If you don't really try to get into film school, what will you really try to do? Don't be afraid to fail, be afraid to give anything but your best.

8. PREPARE FOR YOUR INTERVIEW

After several exhausting months of waiting, an email comes, usually when you least expect it. "You've been invited to interview."

If you're within the United States, you should try and do an in-person interview. There's really no substitute for in-person interactions. If this isn't possible, don't fret: the preparation process is the same.

In your interview, you will likely meet with a handful of faculty members, who will ask you the same questions as they do all the other applicants. They will have selected you for a number of different reasons, including your application, which you now wrote six months ago, so a good first step is to review those materials.

As you go through the materials, which hopefully still ring true to you, construct a simple narrative for yourself and your interest in filmmaking. The four basic questions you need to answer are:

1. Who are you?
2. What kind of films do you love?
3. Why do you want to be a filmmaker?
4. Why is this school the right place for you?

Most interviews will revolve around these four questions. Spend some time thinking about these questions, and how you will connect the dots in between; make sure that the films you mention as favorites tie into the other questions. Every person is unique, to be sure, but again, you're a storyteller; storytellers create just as much meaning through what they don't say as what they do. Create a simple through line for your life, interests and experience, and you will come off miles ahead of the competition. If you're interested in two strong reads on pitching, I recommend *Good in a Room* by Stephanie Palmer, and *Life's a Pitch* by Stephen Bayley and Roger Mavity.

Spend some time coming up with simple, memorable answers to these questions, then rehearse with a friend, partner or relative. You don't want to come off like a robot, but you also want to stay simple, memorable and direct. Most schools will interview three to four times the number of candidates that they will ultimately accept, so even here the competition is stiff. You can't guarantee your acceptance, but you can give yourself a fighting chance.

9. IF YOU DON'T GET IN ON YOUR FIRST TRY

Film school admissions are ridiculously competitive. Rest assured that people do get in on their second and even third times applying; there were members of my graduating class who did just that.

If you're an undergraduate applicant, this is the time to complete your degree in another field, get good grades, gain some life experience and perhaps apply to graduate film school. As a graduate applicant, maybe some additional time and life experience will have the same benefit.

If you pulled an all-nighter to finish your application, now might be the time to go back to the beginning of this chapter and try to be more organized in your approach if you choose to reapply. First drafts of applications are not for university admissions boards. You deserve to give yourself the best possible opportunity to be admitted.

Take a month off and revisit your application materials: What could be stronger? What might be missing? Ask your friends and family to do the same. Constructive feedback, coupled with strong organization, greater maturity and some new, interesting life experience might be what your application needs to be successful.

If you've tried several times, or were never that enthusiastic about film school to begin with, remember: film school is optional. Plenty of successful filmmakers got where they are without formal training. It's not a medical license.

If your heart is set on film school, work toward reapplying: assess your weaknesses, make more creative work, and try again. Remember Rainer Maria Rilke's wise words:

> That something is difficult must be all the more reason for us to do it.

For International Students

The United States has the largest and most powerful film industry in the world, one that draws talent from across the globe. As a nation, the United States also has a very specific culture, immigration policy and financial system that is probably quite different from that of your home country. I am not an immigration attorney or an accountant, but it's important to understand some basic characteristics of the American system. This chapter is based on extensive conversations with international students about the things they wish they'd known before they lived and studied in the US.

1. AMERICAN BASICS

As an international student, you will be facing a host of issues that most Americans never consider. Here are a few basic points you'll need to understand for your transition into the United States.

1. Visas

As an international student, if you want to stay in the United States after graduation, you must accept that dealing with visas will be a huge part of your life. From the moment you arrive in the United States, your student visa will be a ticking clock for your ability to stay in the country. When your visa expires, you will need to transition into your next one, be it an O1 (for artists of extraordinary achievement), an H1B (for employees sponsored by their company), or one of several other options. At the end of your program you will most likely be eligible for Optional Practical Training (OPT), which will allow you to work in your field of study (and only in your field of study) for 12 to 18 months after you graduate. A final consideration is that many visas will not allow you to work jobs outside of your university while you are a student there.

The visa question will be an added pressure for you. You'll need to make connections, find a job, and get your projects going on a fairly tight deadline, because if you don't, you won't have a way to stay in the country legally. Your program will be stressful on its own, so it's not worth having a panic attack right up front. Don't obsess over this initially, but do keep it in mind. One way to approach this early on is to ask any young, professional foreigners you meet how they went through the visa process. Their experiences may help you create a mental framework for your own situation. Carefully research and examine your options and what you need to do to prepare. If you are serious about staying in the United States after film school, this will be a project like any other.

Also: *Do not overstay your visa.* If you are declared unlawfully present in the United States, you can be barred from reentering the country for periods of several years to a decade.

2. Credit Record

The United States is a country driven by debt, also known by the friendlier word *credit.* Every American has a credit score, which rates their reliability as a borrower. The scale itself ranges from 150 to 800, with 600+ rated as "average," 700+ as "good," and 750+ as "excellent." Credit scores are problematic for a foreigner because, having never lived and borrowed in the United States, you don't have one. This is especially difficult because a person's credit score is used for everything from apartment rentals to buying a car. As a foreigner, you will thus need to plan ahead carefully.

It takes time to build a good credit score, so you will need to get a credit card as soon as possible upon moving to the US (yes, this might be part of why we had a financial crisis). To get a credit card with low credit, you will probably have to give a bank cash as a deposit, against which they will give you a credit card. You should immediately start using it and paying it off monthly. As you adjust to the system, you can open more credit accounts to build your score. Again, play it safe: if you fail to pay your credit card payments, or overborrow and can't afford it (a favorite American pastime), it will hurt your credit score and thus become self-defeating. Welcome to the land of the free.

3. Social Security Number (SSN)

This is a nine-digit number that identifies you and will be used for countless tasks in the United States, such as getting paid and getting a driver's license. The paradox here is that as an international student, you will likely not get a social security number until you're on your OPT year. Not having an SSN will make certain things more complicated, like buying a car (almost essential in Los Angeles), activating a utility account, or finding an apartment. The solution for this problem will generally be cash. If you have some ready, you will be able to deal with some of these problems. Just know that some landlords will demand a higher security deposit, and you will probably need to pay for your car in cash.

4. Health Care

Although things are slowly changing with the Affordable Care Act, health care is still very expensive in the United States. This is not something the

government takes care of for its citizens. Individuals have the responsibility for understanding their coverage and paying for it. As a film student, you will most likely be covered through the university during your enrollment (for a fee). The Affordable Care Act makes many people with a low income (read: recent film school graduates) eligible for substantial discounts on their health insurance premiums. But as a foreigner, depending on your legal status, you may not be eligible for them. Use your time in the States to familiarize yourself with how your policy works and basic American health care concepts like HMO, PPO, deductible and out of pocket, so when you have to choose your own policy you'll know what the hell people are talking about.

Again, this is meant to be a simple primer in some of the issues you will face as an international student living in the United States. *You must do your own research as well.*

2. SPECIAL FINANCIAL CONSIDERATIONS FOR INTERNATIONAL STUDENTS

As an international student, many film schools will require you to prove in advance, through bank statements, that you can afford their tuition. This means that you will need to provide a bank statement that has all of the money you need for the year, or a combination of a bank statement and a letter from a funding board like the Fulbright Commission, to prove you will be able to afford school. This is something else to consider while preparing your applications (which may include applications to funding sources).

If you apply to a funding board like the Fulbright Commission, it becomes a bit of a chicken-and-egg battle: you can only get the funding if you get into film school, and you can only afford to pay for school if you get the funding. Unfortunately, unless you're independently wealthy, there's not a lot that can be done here. Also understand that the funding amounts for scholarships like the Fulbright vary from country to country; be sure to understand how much you will actually receive. Even with scholarships, the high cost of American film schools often requires international students to take loans in their home countries to cover the full amount of attendance.

Be sure to do extensive research on any possible funding opportunities to study in the United States. Many governments and cultural institutions support at least one year of study abroad. Any financial help you can get will not only allow you to attend, but also keep you out of debt when you return.

As an international applicant, it's thus important to add a period of funding research and applications to your film school application calendar. The application deadlines for these funding sources are separate from the ones for film school, so give yourself adequate time to prepare.

3. LEARN REALLY GOOD ENGLISH

This may seem like an obvious point, but in the United States you will be studying and communicating in English. America is not a nation of polyglots; do not expect anyone to speak your native language at your university, except perhaps the odd international student.

As an international applicant you will most likely be required to take the Test of English as a Foreign Language (TOEFL). This will test your basic ability to study in the US; it is no guarantee that you will thrive at a party among 20 drunk Americans arguing about HBO. Any class you can take to improve your speaking and listening abilities will be essential. Many film school classes consist of "war stories," where successful Hollywood and independent filmmakers come into the class and talk about how they got their films made, usually very quickly and using a lot of industry lingo.

One way you can prepare for these situations is to listen to podcasts in which filmmakers share their war stories. This has the twofold benefit of increasing your knowledge of the US film industry while also improving your listening comprehension.

Americans will always tell you that you speak great English; this is because we come from a country where foreign language classes are generally slept through between the ages of 12 and 17. Anyone who speaks English remotely well thus seems like a mini-Mozart to us.

All this is to say that you need to make sure that you actually speak great English; film school is not designed to teach you a second language, though it will certainly improve it. Language classes in your home country will be more productive and less stressful than trying to figure out what a Hollywood producer just said about his Ferrari.

On a final note, though excellent English is absolutely mandatory, you don't necessarily need to lose your accent. The American film industry has been fueled by a constant influx of foreigners. A corollary to our relative provincialism when it comes to speaking foreign languages is that we are an immigrant nation, often fascinated by people from foreign countries. Your home country is an indelible part of your identity; use it as a strength.

4. CATCH UP ON AMERICAN POP CULTURE

Americans watch a lot of television and movies, generally of a very specific kind. At any given film school party right now there are probably four circles of people discussing the same line from the same obscure television show. To a foreigner, it can be disorienting.

Take some extra time with the resources and publications in this book to catch up on the major films and television series in America at the moment. They will shape the discourse of your fellow students and faculty when you arrive in the United States. This knowledge, combined with your awesome English skills, will go a long way toward helping your transition into your new motherland.

5. KEEP A FOOT IN YOUR HOME COUNTRY

As an international student it's very important to understand that you are building a professional network in a country you may be forced to leave. It's thus important to build and maintain a network in your home country, all while learning as much as you can about the US industry. An international education at a prestigious US film school can be a great selling point for you later on as you seek jobs and collaborators in your home country.

Try to send occasional updates on your progress to your network back at home, and always be on the lookout for people from your country at your school and elsewhere. If you can afford it, holidays can be a great way to return home and say hello in person; hopefully you will have plenty of great Ferrari stories to share.

Many funding sources, including the Fulbright, have mandatory home country residency requirements for grantees. This means that after your year of Optional Practical Training, if you've been funded by one of these organizations, you probably will be forced to move back to your home country for a set period of time. Keep this in mind as you move through film school; if you know you're moving back home, even for a while, make sure to keep your options and network alive while you're away. Otherwise you could be facing a rude awakening when film school ends.

6. EMBRACE YOUR DUAL IDENTITY

The ability to navigate and communicate in multiple cultures is invaluable. Never undermine your identity; see it as a source of strength. As an example, many international students return to their home country to shoot

their thesis films. Something about the perspective of having been away, combined with the joy of returning to their own culture, often make these some of the strongest student films around.

Being a foreigner will present you with many added difficulties, but it can also make you unique. Take the opportunity to discover and meet with the people in the industry from your own country; oftentimes they will be thrilled to have a discussion in their own language, and perhaps to help someone who, like them, decided to brave the currents of a foreign culture.

7. STAYING IN AMERICA: THE POST–FILM SCHOOL DASH

For obvious reasons, many international students who study film in the United States want to stay there after graduation. Understand now that the ability to do so is usually the result of careful planning, hard work and more than a little luck. Relationships with companies who can sponsor you will be crucial, as will be the success of your own creative projects.

At the end of film school most of the international students will go into crunch mode, each driving desperately for that one connection, job or project that will allow them to stay in the country. It may not seem fair, but again, if you plan for this, it will be less of a shock when it actually comes. Constantly analyze and revise your strategy for staying in the country, making it as specific as possible. "Maybe I'll get a job at X company" is not nearly as helpful as "I already have job interviews at three companies which I know have a track record of sponsoring foreigners for their visas. I have a good shot at getting the jobs because I have multiple marketable skills (i.e. writing great coverage, managing phones) that the job requires, as well as some excellent recommendations." Those recommendations will most likely come through the internships you do while you're still a student, so make sure to do several.

To give another angle on all this doom and gloom, here are the wise words of an international friend based in Los Angeles who has made it through this process:

> The bright side is that, as trite as it sounds, where there's a will there's a way. In general, this country is pretty good about keeping people who can add value to its society, so make sure to build relationships of trust with both individuals and companies, create interesting projects and don't be ashamed to *publicize*

and record your success. USCIS (United States Citizenship and Immigration Services) will need tangible proof of your "added value." Also, for God's sake, don't break the law, and don't mess around with your legal status. Respect expiration dates on your visa as if they were sacred. Never extend your stay past the expiration date on your visa.

During Film
School

When you look at the exceptionally creative work of Masters, you must not ignore the years of practice, the endless routines, the hours of doubt, and the tenacious overcoming of obstacles these people endured. Creative energy is the fruit of such efforts and nothing else.

Robert Greene, *Mastery*

Minimize Debt

If you are interested in applying to film school, and do not have significant family or personal wealth, or a full scholarship (some exist), it's likely that you will graduate in significant debt.

What does significant mean? For graduate directing students, even at a public school like UCLA, it often means well over a hundred thousand dollars.

If you're an undergrad and your parents are paying for college, don't breathe too easy. Filmmaking is a challenging financial choice, and the skills you will learn in this chapter will serve you well as you chart the path to your filmmaking career. Take heart: financial planning and understanding is a mandatory skill for any successful person.

In non-directing majors, your debt load will be lower, but it will still be a factor in your future choices.

With the proper mindset, it's possible to save thousands and thousands of dollars in film school, even if you still go into significant debt. This is not a miracle diet; it revolves mainly around good planning and self-discipline. The virtues of discipline, courage and perseverance not only apply to your creative life but to your financial life as well.

1. CALCULATE YOUR NET WORTH

Before you begin film school, it's important to take financial stock of your life. The decision to join the film industry is an exciting one, but because of the financial insecurity involved, it's especially important to be rigorous in your financial planning and discipline. We're all artists, I know, but the artists who achieve their dreams do so in part because they carefully manage their financial life in order to pursue them.

The foundation of this process is a calculation of your net worth. This is the amount of money that you currently have to your name. It is also what, financially speaking, you have to show for the life you've led up to this point. This may be difficult to stomach, but if you're serious about a filmmaking career, you will have to develop financial acumen. Unfortunately, despite the massive loans that film schools offer to their students, they offer little in the way of financial planning to manage all those loans.

Remember, for at least the first decade or so, filmmaking will be an investment in yourself: any personal films you make or screenplays you write will be unlikely to pay you in money. You must thus be able to carefully calculate

your time and resources between the jobs that pay you and the jobs that fuel your soul. If you understand how much money you make, as well as what you spend it on and why, you will be able to align your spending with your values. This is one of the single most important choices you can make on the road not only to becoming a filmmaker, but also to leading a fulfilling life. So let's put together your balance sheet to determine your net worth.

We are going to look for assets (things you own) and liabilities (things you owe). First, let's start with assets. Add up any:

Liquid Assets
- Cash on hand: piggybanks, any cash in your closet, the cash in your wallet, etc.
- Savings accounts.
- Checking accounts.
- Savings certificates or certificates of deposit.
- US savings bonds.
- Stocks, bonds and mutual funds, at their current market value.

Fixed Assets
- The current value of your house or car.
- Itemize anything you own: baseball card collections, DVD collections, etc. Anything you can sell, give a realistic estimate.
- Your computer.
- Be creative with this, and give it some thought. If you're moving to a new city, maybe now is a good time to have a garage sale and liberate yourself from your junk before you have to move it all.
- Give all fixed assets an estimated cash value.

Now let's look at your liabilities, or all of your debts.

Liabilities
- Any outstanding loans, student, car or otherwise.
- Any outstanding credit card or medical bills.

Be ruthless with your liabilities: the more accurately you can calculate your expenses, the more accurate your borrowing and budgeting will be. No one gets brownie points for lying to themselves about their amount of debt. The only people who benefit from poor financial planning are the loan companies.

Now calculate your net worth:

(Liquid Assets _____+ Fixed Assets _____) – Liabilities =

_____ Your Net Worth

Take a deep breath. This is where you're at financially going into film school. Be proud for getting this far; these are the kind of assessments that responsible filmmakers make.

Keep this number present with you. It will be the beginning of our next step, the Debt Scorecard.

2. THE DEBT SCORECARD

Now that you have your total net worth, you're able to more accurately estimate how much debt you will actually go into with film school. Again, this is not fun, but it's absolutely essential. We're from the defunded American generation, so this is our cross to bear. If we do this responsibly, it will be infinitely more bearable than if we pretend like its not there. In film school I saw some people go over $200,000 in debt due in part to a lack of willpower and proper planning. Over 20 years, at 6.8 percent interest (the current standard for Stafford Loans), that means you will pay almost double the principle, or $366,000.

The Debt Scorecard will be your monthly overview of your financial situation. Every month, you will calculate your net worth, then deduct your loans. I like to use a simple spreadsheet for this. Here's the calculation:

Net Worth – Liabilities = Current Debt Level

Keep this updated monthly, and try to keep it someplace visible.

Why is this so important? Because film school will give you a thousand opportunities to spend the extra dollar somewhere: a nicer apartment, paying a crew member instead of finding someone to do it for free, buying that little present for yourself that you don't really need.

It's very difficult psychologically to keep in mind that those large sums of money coming into your bank account are actually cancerous debt. Keeping the debt scorecard will force you to remember that all that money comes at a price, and that you should borrow as little as possible. It will also help you make trade-off decisions. For example, I spent a little extra money on my thesis film to shoot it early. My justification: shooting early allowed me to graduate early and thus save a boatload of money on tuition, living expenses, etc.

With the debt scorecard, you will have a financial roadmap for the choices you're making. During school many, many students simply close their eyes to their growing cesspool of student loans, even going so far as staying in school longer to avoid repayment. By staring down the problem of loans before you borrow, you will empower yourself to understand what you're getting yourself into, and hopefully make more responsible choices when it comes time to borrow again.

Keep your debt scorecard with you from Day 1, and you will always have a clear understanding of how much you're borrowing and why. That way when temptation comes, you'll have a crucifix you can use to ward it off.

3. TRACK ALL EXPENSES

This is the second cornerstone of financial intelligence. Starting now, you must always track your expenses. Every dollar must be accounted for. This can be done in an analogue fashion by collecting all receipts and carrying a notebook, or digitally through collecting receipts and entering them on a variety of apps. Be sure to categorize each expense (coffee, eating out, rent, etc.) At the end of every month, calculate how much you've spent and earned, in total and for each category, then compare your spending with previous months.

By tracking your expenses, you will be doing two things:

1. Making yourself conscious of how much money you spend and why.
2. Evaluating whether you really need to spend as much money as you do, and on what.

When you start tracking and categorizing your spending, certain trends can become painfully obvious: little items like takeout coffee, lunches and inane little widgets can cost you hundreds of dollars a month. If you look at each of these dollars as potential debt, you can start adjusting your life and habits to reduce them. Make your own coffee at home, make your own lunches, shop at a cheaper grocery store, don't buy new clothes, choose the cheaper apartment to live in, etc.

Make sure to spend time every month giving some careful thought to your expenses. An excellent book, *Your Money or Your Life*, advises readers to evaluate each expenditure against their life's purpose. If your life's purpose is to become a filmmaker, and you're spending hundreds of dollars a month on items that don't contribute to that goal, maybe it's time to reevaluate

your habits and spending. If spending aligns with your goals and values, you will exponentially increase your possibility of success. Again, be ruthless; it's very easy as a filmmaker to make everything feel like it contributes to your career. Now is the time to get in the habit of evaluating your expenses versus not only your own satisfaction, but also the results they bring.

4. TEACHING ASSISTANTSHIPS (TASHIPS)

Now comes the section so many film students, particularly at the graduate level, are curious about. Teaching assistantships are jobs within the school where students assist professors with classes and are paid through tuition reduction and a monthly salary. It is very difficult to gauge and budget TAships when you're applying to film school, however, because, put simply, the amount of financial support can vary widely from one student to another.

This is because, as at any institution, class and course sizes and lengths vary. The second main reason is because professors generally decide who they want to work with, usually based on their preexisting relationships with students. It's difficult to gauge in advance which professors you will get along with, or who will want to help you, before you are actually at school and interacting with them. A certain degree of luck always factors into these decisions, but there will always be a political element as well. Major TAships, which give significant fee reductions, often are decided through an interview process, and are generally reserved for students in the final years of their respective programs.

As much as possible, try to investigate the structure of TAships at the schools you're interested in, but understand that there is generally no set amount of financial aid and TAships that universities give to each student. A good strategy when you get to school is to talk to and befriend the people in the TAships you would like to have, as well as maintain good relationships with the professors you want to work with. Making people aware of your financial need is important, but again, most people in film school go into a lot of debt, so this will not make you stand out in the same way that professionalism, hard work, gratitude (read: not complaining) and kindness will.

5. GET A PART-TIME JOB (PAY DOWN INTEREST)

Every possibility you have to pay down debt, or to borrow less to begin with, will be to the advantage of your art. Many universities offer part-time administrative work on top of teaching assistantships. A part-time job, especially in semesters where you're not in production or don't have a teaching assistantship,

will provide an essential source of income that is not derived from loans. I worked in the admissions office at UCLA for two quarters, which also had the advantage of being on campus and thus required no commute.

Any money you can put toward paying down your interest will pay you back a thousandfold upon graduation. Working a job will also keep you humble, grounded in financial realities, and force you to properly budget your time and energy. Film school is not an artist colony; it is a grueling and focused dedication to your craft. Building a strong work ethic will only help you in the long run, because after you graduate you will definitely have to work a job while you develop your projects.

6. BE A RESIDENTIAL ASSISTANT (FREE HOUSING)

It's already been established that New York and Los Angeles are very expensive cities to live in. Even student housing, which provides the advantage of being close to campus, will generally run well over a thousand dollars a month.

One way to cut down on this debilitating expense is to become a residential assistant (RA). In exchange for free housing and a monthly stipend, you will open drunk people's apartment doors at 3:00 a.m., help them fish out things they got stuck in the oven and possibly fix their dishwashers. Yes, this is a humbling job, but think about it this way:

If you would normally spend $12,000 a year on housing and you spend nothing, over the course of three years that would be $36,000 saved, plus whatever you earn from your monthly salary. This is probably the best deal around for graduate and undergraduate students in large cities, and a bold step beyond what any other part-time university job will give you.

Yes, you might be annoyed to miss out on a party or two, but you can take comfort in the fact that the people at that party are going to have to pay off the equivalent of a new BMW after they graduate, while you will have more financial freedom to pursue your projects.

Research these opportunities early, as there is generally an application process. Depending on your major, you may not be able to work a job in the first year of your program, but keep an eye out for these opportunities in your second year. Befriend fellow students who work these jobs, and you may be able to get a recommendation. Remember, twenty to forty grand is no joke.

7. FOR DIRECTORS: AVOID THE ARMS RACE

Peter Sollett, director of independent films like *Nick and Nora's Infinite Playlist*, learned a valuable lesson while a student at NYU Film School. His second-year film was an expensive flop. He had spent a great deal of time and money putting together a huge team to get the fluid camera style and high production values visible in a certain class of student short films. When he showed his film, he got the highest compliment anyone could offer: "It looks like it was shot on 35mm."

While the film looked great, Sollett was unhappy. The film was plagued by the weak storytelling and performances that so often identify student filmmaking. He swore that his next short would be different, and as a result *Five Feet High and Rising* used all original locations, without lights or permits. Sollett photographed the film himself with a minimal crew, and, after a lengthy casting process, improvised with non-actors based on a detailed treatment. The result is astonishingly beautiful, and won prizes at Cannes, Sundance and South by Southwest. It also launched his career.

The lesson here is that budget does not equal quality. The single area where directing students have the most control over their debt level is the cost of their student films. Students know this, but there's a strange form of blindness that creeps into place when they budget their own films. Part of this is what I call the arms race: many students spend ridiculous amounts of money because they see their classmates doing the same. There is a strange belief that money spent has an essential impact on quality, especially at the short film level.

It's not an easy thing to admit, but as filmmakers, we enter film school at our weakest. This is because we lack filmmaking experience. The impulse can be to spend a fortune to execute your grand vision, but what often happens is, lacking practical experience, those large sums of money end up as shiny glitter adorning a turd.

Understand that the filmmaking process is massively complex and takes an inordinate amount of time and practice to learn. This is another way of saying that your early student films will probably not be as good as your later ones. This makes obvious sense: as human beings, we hopefully learn from our mistakes and the mistakes of our peers.

The second major point to be made here is that the larger the project, the more work will need to be done on the film's production, which you will inevitably be a part of. This gives you less time to do the work of a

storyteller: casting and directing actors, refining the script, developing a visual style, etc. Smaller projects, with less extensive producing problems, often yield better results simply because the directors are focused on directing, not producing, their film.

If you're going to spend a chunk of money on a film, you should spend it on your thesis film, the film on which you will have the most experience as a director, and ideally the strongest sense of story and directing you will have while still in film school.

There is no award at film festivals for "most expensive student film," or "most elaborate student production." In fact, many of the greatest innovations in cinema, from David Lynch to Jane Campion, have come from people coming up with creative solutions to financial obstacles.

The best way to deal with this is to set a small budget for your initial films, then raise that budget slightly for your later films. Create projects that do not require a massive amount of money, and you will spend more time as a filmmaker and less as a film financier.

8. FOR DIRECTORS: BUY AN AFFORDABLE KIT

The worst excuse for a director to not make a movie is "I don't have a camera." You can make a movie without actors (hint: documentary), but you can't make a movie without a camera. Nonfiction filmmaking is an excellent, accessible way to learn your craft, and having a kit is one way of getting into that.

Filmmaking, like any craft, revolves around endless hours of practice. A small, affordable kit will allow you not to be dependent on the school's equipment, and will give you no excuse not to constantly practice your craft. As you continue to develop your skills, perhaps you'll see certain areas that you could improve upon, like working with actors or visual storytelling. With a small affordable kit, you'll be able to go out and shoot small exercises, or even complete short films, to practice certain skill sets.

Your kit can also be used to make your early student films, which can cut down on the cost of equipment rentals, etc. Again, there are no prizes for "most expensive camera used."

As you transition into the professional world, having a small affordable kit will also allow you to do for-hire documentary work, as well as small industrial/journalistic pieces. At the lower end of the market, companies often

require filmmakers to own their own gear. You could even make your first feature on it if you're so inclined, which would be one less obstacle to actually making your feature.

The final upside of having a kit is that it's a tick in the asset column: if you end up not using it, you can always sell it for some extra cash.

9. LEAVE OF ABSENCES

There's a possibility that, as a graduate student, you might have a quarter or semester where you'll primarily be writing, rewriting, doing research or in preproduction at some distant location. Or perhaps you're in some other situation where most of your creative time will be dedicated to work that's not directly associated with a specific class at your school, or require the use of its facilities.

Some students use these moments to take a leave of absence. In this case they don't pay tuition or attend classes for a semester, with the knowledge that they will re-enroll afterwards to finish their degree.

If done strategically, a leave of absence can have an economic benefit. It generally works well for students who are very organized, have completed or nearly completed all of their graduation requirements and have a strict plan. Otherwise many students go into a leave of absence never to return. As with everything, it's very important to plan for these decisions, and to maintain your discipline and purpose without the structure of the school. Be sure to look very carefully at your school's requirements for a leave of absence; you don't want to get into a situation where you might have to reapply to your own school in order to be able to graduate.

Practice Your Craft

Many characteristics once believed to reflect innate talent are actually the result of intense practice extended for a minimum of 10 years.
K. Anders Ericsson, Ralf Th. Krampe and Clemens Tesch-Romer,
The Role of Deliberate Practice in the Acquisition of Expert Performance

Film school goes by in a blur. It's such a difficult, remarkable, creative time that before you know it, you're giving the loan company your account numbers and scrambling to earn an income.

Film school should be a time of exploration and self-discovery, but the two most important things you will need to leave with are a professional network and a creative portfolio. This chapter focuses on some strategies with which you can approach the overwhelming number of choices that film school will offer you, all while keeping your looming graduation in mind.

This book is not about how to write a screenplay or direct a film, but rather about the process of film school and how to get the most out of it. I'm therefore going to focus mainly on the big picture ideas. I'll leave the individual crafts to the experts, represented in the extensive reading list in Appendix D.

1. MAKE A CREATIVE PLAN (SET GOALS)

As you enter film school, it's important to define what you hope to get out of it. Obviously, this is a difficult task, as you're not actually in film school yet. But at this point you should have some idea of what you'd like to do after you graduate. These are the main things you are going to want to build while in film school.

1. A Creative Portfolio

This will be the body of work that you use to approach the professional world after you leave. This could be a collection of completed short films, a strong feature screenplay, a cinematography or editing reel, or a strong producer's pitch. Developing this body of work will be your main task in film school, and your goals should center around it.

It can be very easy to get distracted from this goal with the plethora of classes offered by film schools. One way to approach this is that for every semester you spend in school, you should have one completed piece of work to show for it. This is difficult, but the important things in life should be difficult. Always make the hard choice, which in this case will bring you an

end result, whether it's a short screenplay, a revised feature, an edited film, or another piece of completed work.

Understand that people do not create masterpieces on their first try. Very often the only film or screenplay students show to the world will be the last one they make, which shows the cumulative learning of their entire time in school. It is thus important to make multiple projects, write multiple scripts, and so on.

A solid creative portfolio for a directing student could consist of the following:

1. A festival-quality short film.
2. A low-budget feature screenplay that fits the tone and genre of that short film.

For a screenwriter it should be a polished feature screenplay that demonstrates your strengths as a writer.

For cinematographers it would be a high-quality showreel and website that they can use to market themselves. For editors it would be a similar showreel.

For producers it can be a little more complicated, but in addition to having at least one festival-quality short film, one goal could be to have a fully developed, budgeted and scheduled feature film project.

Your creative portfolio should directly reflect your goals as a filmmaker. If you want to make documentaries, make a series of short documentaries, then write a feature treatment and make a fundraising trailer for a feature.

If you chart your own path, and make sure you stick with it, leaving school will be a lot easier than it is for most, especially if you have placed equal focus on the second essential takeaway of film school.

2. A Strong, Diverse Professional Network

This should include fellow film students, professionals you meet through internships and other work, and the creative collaborators you hope to work with in the future. It should include the people who give you the best possible feedback on your work, who can help you throughout the filmmaking process, as well as the people who might be able to get you that first all-important job in the industry. This means that while you're in school you should be doing everything you can to form connections in the area you want to go into: if it's television, then intern for a TV show, or a production

company that could lead to an internship on a TV show. You need to make as many connections as possible while you're still able to work for free (outside of your part-time job, of course).

The creative portfolio will be the focus of this chapter, the professional network the focus of the next one.

2. FINISH EVERY PROJECT

The single most baffling aspect of film school for me was the realization that many students never finish their films or screenplays. There are many reasons for this, but the main ones are procrastination, perfectionism and simple fear. Many students will tell you that they can't afford to finish their films, but in the digital age, this simply isn't true. They may not be able to finish the film with expensive professionals, but they can certainly take a film all the way through postproduction and festival submissions.

In film school many things you make will not work. You will cast the wrong people, direct them poorly or eventually discover that your story makes no sense. This is a universal experience, and an essential one. You cannot learn without failure, suffering and confusion. It's just that simple. The same applies to the screenplays you write, the projects you develop as a producer and the films you shoot as a cinematographer.

Each project you create in school is more than about learning the craft of filmmaking, it's about learning the discipline, courage and perseverance that's required to make and complete projects. By overcoming your fear, laziness and despair to finish your projects, you are learning not only how to make films, but how to be a filmmaker.

As a director, finishing films, however cheaply, teaches you the magic of postproduction, what can be improved and what can't, how to work with a sound designer and colorist, and, most importantly, how to generate the willpower to overcome obstacles, as well as how to face the inevitable rejection that comes from putting your work into the world. This is a mandatory part of being a filmmaker, and Every. Single. Successful filmmaker has gone through it.

3. LEARN TO GIVE AND RECEIVE GREAT FEEDBACK

Filmmaking is an intensely collaborative endeavor, and feedback is the blood that courses through its veins. As a film student you will give and receive feedback on screenplay drafts, actors' performances, producers' pitches and

presentations, cinematographers' images, props, wardrobe, sets, rough cuts, fine cuts, sound design, color correction and more.

Later, if you move into the industry, this will be one of your most important professional skills. Producers, managers, agents, actors, financiers and all of the power players constantly give feedback on projects. As a creative person it's up to you to learn how to interact with them in a professional, productive way. As you progress in your career you will both give and receive feedback countless times; it will form the basis of many of your professional relationships.

There is no single more valuable person in your network than the person who can look at a piece of creative work, then give you an articulate summary of its strengths and weaknesses, as well as offer possible solutions.

1. Basic Tips on Giving People Feedback on Their Projects

a. Always Start with the Positive

There is always a merit or virtue to a project you can point out to the filmmaker. Feedback is always a nerve-wracking process for the recipient, and hearing something positive calms them and makes them more receptive to what you're about to say. Also, in the maelstrom of rewriting or the editing room, you want to make sure that positive elements of a project are not lost. Praising the strengths of a work can often be as strong a tool as calling attention to its weaknesses.

b. Always Position Yourself as Someone Trying to Help the Project

Ideally, you are always helping the filmmaker express her vision and make a great project. If you express your notes in relation to this goal, the filmmaker is much more likely to be receptive to them. "If, then" statements can be great to this effect. For example, if you feel a performance is weak, try to frame that in terms of a broader positive goal: "In this scene I feel like the performance is not as strong as in other areas. Perhaps if you use more reaction shots here, then the character's intentions will be more clear."

c. Start with the General, Then Move to the Specific

It's often good to give overall impressions upfront: which characters, scenes, stylistic choices are working well, and which ones could be improved. This will give a framework as you move into specific choices the filmmaker made.

Stanislavsky, the founder of modern acting, once said that "generality is the enemy of all art." Only giving general praise or criticism can often leave the filmmaker stumped as to what they can actually work on. Work from your general impressions down to specific moments that illustrate your broader points. "This line here, this shot, that character," etc.

d. Frame Things in Terms of Your Personal Experience

Another way to help notes land properly is to talk about how you personally experienced the piece. When you frame things through your experience, it makes it easier for a filmmaker to accept criticism: "At this moment I felt like this was going to happen, but then it didn't, and I felt disappointed." "I laughed here, but this joke over here felt repetitive, or not in keeping with the tone."

2. Receiving Feedback

Creative projects often feel like our children, and no one wants to hear that their kid is a little slow or ugly. What you will learn through the process is that great feedback, and the people who can give it, are invaluable for creating good work. It's simply not possible for us to see our work objectively without the help of others. Films are made for audiences, and it's important to get into the practice of soliciting feedback at key moments through a project's development. Here are some pointers on receiving feedback.

a. Learn to Listen

Don't interrupt the person who's speaking. They've given you and your project their time and thought, so let them speak.

b. Learn to Be Open and Collaborative

Sometimes the best ideas for a project are not the ones that you personally come up with. Learn to leave your ego at the door and focus on what's best for the project. If you continue to rise up in the film industry, you will receive many different reactions to your projects. Some might be ridiculous, but others will be very valuable, if you know how to be open to them.

c. Take Written Notes

You will always receive more feedback than you can remember. It's therefore crucial to take written notes of what people say, no matter how banal.

Oftentimes a note that baffles you on a first draft will make perfect sense several drafts down the line.

d. Use Questions to Clarify Points

If you're confused about something someone said, after they finish speaking it's good to ask them a few questions to clarify. Learn what questions you need to ask to truly understand what's not working for someone (it's rarely what they think isn't working). Screenplays are large, complex emotion machines, and oftentimes if someone has a negative reaction to something late in a script, it's because something in the beginning isn't working.

This is a moment where you can also express your intentions to see if they got across. If they didn't, it can often be good to discuss certain strategies for making intentions clearer, or perhaps whether you should abandon some altogether.

These points only scratch the surface of one of the great unseen arts in filmmaking. Who you get feedback from, how you give it, and how you implement it is one of the single most important skills a filmmaker can develop. Give the feedback process your full attention, and your films and relationships will benefit to no end.

4. DEVELOP A FEEDBACK CIRCLE

There is no one more valuable than a friend whose opinion you trust. That friend will be a bulwark against the difficulties you will face while getting your projects made. Try to build a circle of a few close friends and collaborators you can go to with new projects. If you are as good at giving feedback as they are, it will be a mutually beneficial relationship and one that will be able to last.

A writer's group can often serve not only as a source of feedback and camaraderie but also of accountability. If you have to produce material on a weekly basis, there will be far less excuses for you to avoid your calling.

5. LEARN HOW TO DO RESEARCH

The *Oxford English Dictionary* defines a cliché as: "A phrase or opinion that is overused and betrays a lack of original thought."

This is one of the single most common criticisms of student work: a lack of originality. Film festivals are besieged every year with the same derivative

copies of Quentin Tarantino and the Coen Brothers. As you continue on your path as a filmmaker, you will see films where the characters, worlds and stories feel like nothing more than a rehash of whatever filmmaker is popular at the moment.

Obviously there are a lot of causes for unoriginal, derivative filmmaking, but one that is seldom discussed is a lack of research.

The reality is that most writers have never personally experienced the events they describe, nor do they need to. Most filmmakers (with some notable exceptions) are not drug addicts, criminals or space cowboys. Writing is about the imagination. For most successful writers, then, research is how they cover their gap in knowledge about subjects they have not personally experienced.

Research is an essential part of the filmmaking process. It allows you to experience the worlds you write about first-hand, to collect telling details that will enrich your storytelling and to figure out, through a dialogue with reality, what you are trying to say about the world.

Even if you write about galaxies far, far away, research can be valuable to you. As just one example, what was the concept for *Alien*? Truckers in space.

It's a great concept, but if you've never been a truck driver, spending some time with one, visiting the places truckers live and work, and learning about their world will inflect your characters with a realism that you simply cannot fake. Those tangible details—a coffee cup, a use of slang—can make all the difference for the realism of a character.

The same process applies if you're writing a scientist, a lawyer, a stripper or anyone. It's your job to make these characters specific and interesting, and research is an important part of that process.

Stanley Kubrick was an epic researcher. For a peek into the master's process, check out a ten-volume book called *Napoleon: The Greatest Movie Never Made*, which gives a window into the near-decade Kubrick spent preparing for his biopic about Napoleon, a project he was ultimately unable to make. Inside these ten volumes are thousands of photographs, illustrations, and paintings, all of which document the era of Napoleon's life.

If Kubrick did it, so should you. This applies just as much to non-period pieces. The world is teeming with powerful, real details that can augment the power of your work. Skip them at your peril.

So, how do you do research?

1. Sources of Research
a. The Web

Most research nowadays will start with Internet searching. It can be good to come up with a series of keywords that relate to your project. Do a brainstorming session on a piece of paper, then write out a list of the best keywords. Punch them into your search engine of choice, and start reading.

This will likely give you an overview of your subject matter. Be sure to write down interesting names and ideas in your notebook, or in a separate CHARACTERS Excel file, so you can go back and follow up on anything interesting.

You don't want to be the filmmaker whose knowledge doesn't extend beyond Wikipedia. Yes, read the Wikipedia page, but don't settle for it.

Use the Internet as a way to get an overview of your subject matter as well as ideas for future research. The Internet is rarely a source of "deep knowledge"; much of that is going to come from other places.

b. The Newspaper

Hopefully at this point you're reading a daily newspaper of some sort. Perhaps your film deals with some sort of current event. If so, great, you are now tasked with becoming an expert on that subject. Save and archive articles that relate to your subject.

On a second note, as a daily reader of the newspaper, you can also look for interesting details that you can use for your characters or the world of your story. The articles might not always directly relate to what you're writing about, but something might strike you as useful. Make sure to make a note of that as well.

c. Books

A visit to your local bookstore and library will no doubt give you a host of reading on your subject. Find how-to books, theoretical texts, biographies of major figures and anything your characters might read themselves.

On Amazon, a great way to find reading material is to find a relevant book, and then scroll down to look at the section entitled "Customers who bought this also bought . . ." In this section you can see what other people are reading on a similar subject. This is also a great way to find relevant material.

d. Travel

There's nothing like visiting an actual location to get a sense of how it looks and feels. Bring a camera and a notebook and try to capture relevant details in your mind's eye. What does the weather feel like? The buildings? How do the people talk?

It can also be very important to visit institutions (hospitals, police stations, schools, etc.) that relate to your subject. Where would your characters actually go in the script? Just be sure to call in advance and get permission so you don't get into trouble.

e. Interviews

When you're on location, it can be an excellent tool to meet with people who work in the field you're focusing on. If you're writing about psychology, interview a few different therapists. Ask them about their process, their profession. What's difficult about what they do? Rewarding? Surprising?

If what you're doing is based on true events, meet with people who were there or involved and interview them as well. The truth is almost always stranger than fiction, and often more memorable.

f. Organizations

Many of the people you find to interview may be affiliated with an organization. If you're writing about Alzheimer's, for example, go to a retirement center and try to meet with someone who has the condition. Better yet, volunteer at a center, or contribute to a charity that works on your subject. That way you can learn while also making a contribution to society.

g. Movies (Fiction and Documentary)

It's highly unlikely that you're the first filmmaker to ever approach your given subject. What films have been made about it? How were they photographed?

Watching the work of other filmmakers on the same subject can often help you shape your own approach. It's a bit like Goldilocks: that film was too hard, that one was too soft, OK, so this way would be just right.

h. Photography/Fine Art

Are there major works of photography or fine art on your subject? Make sure to see any major exhibitions or to look at the work of any major

photographers or visual artists who have treated your subject. They can be invaluable visual references for what you're trying to do.

i. Publications

If your characters are in certain professions, it's possible that they'll have some sort of professional journal they would subscribe to. Psychologists, medical doctors, lawyers, law enforcement officers all have periodicals that keep them up to date on developments in their field. What's happening right now in your characters' world? What kind of accolades are given for achievements?

j. Experts

A final place to look is for experts in whatever you're writing about. Maybe your character is a buffoon when it comes to painting, or science or whatever it is. You shouldn't be. An expert can answer some basic questions about the world you're writing about, so that you don't write something absurd.

Again, all filmmakers go through this process in some way or another. Learn how to interview people, spot details, discover what's unique, surprising and interesting about your subject, then integrate that into your storytelling. Audiences can always tell when a project is grounded in reality.

6. DEVELOP A PROJECT YOU CAN REALISTICALLY MAKE AFTER GRADUATION

"Realistically make" generally means "low budget." No matter how successful your short films or screenplays are in school, it's exceedingly rare that newcomers are given the opportunity to realize high-budget, long-form work. The Catch-22 is that you need to have made a feature in order to get a feature made.

Take account of the resources you have available to you, and see if you can develop a story to meet those resources. If your family has a farm in Iowa, perhaps there's a project you can develop for that location. This is not to say that if your love is sci-fi, you shouldn't write a science fiction project. But understand that the more money a project requires to get made, the less likely it is to do so, especially with inexperienced talent like yourself.

There is a form of neurosis with young filmmakers, wherein they constantly develop projects with impossible obstacles to getting made. The films have ridiculously high budgets, can only cast a certain actor, require elaborate

effects, etc. This is not to say that you can never make these films, but the reality is that without having a prior track record, it can be extremely difficult to get a higher budget project off the ground. Write as many stories as you can, but make sure that when the time comes to leave, you have a polished draft of something you could make for cheap. This is just as useful for producers and screenwriters as it is for directors.

Again, filmmakers not only develop films but make them. Give yourself realistic obstacles to overcome, and you will most certainly be able to do so when the time comes.

7. DON'T SWING AT EVERY PITCH (PRIORITIZE)

Film school will offer a cornucopia of choices for classes, projects and collaborations. It can be very easy to overbook your time and creative energy. Upon graduation, many people suddenly realize that they didn't leave with the things they entered film school to create.

It's important to prioritize what you would like to get out of film school, then orient your classes and schedule accordingly. If you want to write several feature scripts while in school, then you would do best to take as many feature writing classes as possible.

It's also extremely important to build creative time into your schedule. This is time when you're not in class or at work, and you have time to write, shoot, plan, whatever you need to do. You must schedule time every day for writing and creative work. If you do not treat this time as important, you will inevitably rush, stay up late and deliver inferior quality work. Planning creative time literally means looking at your calendar and saying, "OK, I need two hours to write every day, preferably in the morning, because that's when I'm at my best. That means I won't be able to take this class, because otherwise I won't have that time." It seems basic, but you'd be amazed at how many people don't do this.

The same goes with participating in creative projects: there will always be someone asking you for your time and effort, to help out on a shoot, read something or otherwise. This is not to say that you shouldn't help your classmates. You must, however, make sure that you are getting your own work done and accomplishing your own specific goals.

Remember that the most powerful classes are often the ones that bring some tangible result, wherein you write a script, make a short film, fulfill a graduation requirement and so on. Leave time for perhaps one interesting

extra class per semester when possible, but don't get constantly trapped in too many commitments at once. Remember that your first priority must always be your portfolio and your network. Better to walk away from a lesser responsibility so your time and effort stay in the right place. As a concrete example, I had to drop a handful of classes in film school, because I realized they were too time-consuming, and that they would affect my ability to make my main creative projects on time.

Also, keep an eye on graduation requirements. Do not leave all your required classes until your final years; this is an easy way to spend thousands of extra dollars on tuition. If you carefully plan when you will take required classes, it shouldn't be a problem to graduate on time, or even early.

The ability to evaluate opportunities against your specific career goals, and to say no to opportunities when necessary, will be one of your most important skills as you move forward in your creative career. You will always have to carve out creative time around paid work. The sooner you develop this ability the better.

Hang your film school goals on your wall if necessary, and refer to them often when you're facing a difficult choice. Ask yourself, Will this opportunity lead me closer to my stated goals?

8. UNDERSTAND THE OTHER DISCIPLINES

Film school is an incredible opportunity not only to learn about your own discipline but also about those of your colleagues and soon-to-be professional collaborators. As a screenwriter, taking a producing or directing class or two will give you an insight into the process of the people you would like to work with. Having that knowledge can help make you a better collaborator.

Ultimately, a film or television show is an ecosystem, wherein each choice radiates throughout the whole process. A screenwriter writes a transition between two scenes, which is then translated into images and performances by the director and cinematographer. Those images are then timed out and placed by the editor. Still later the sound designer, visual effects artists and colorist come in and do their work as well.

For certain crafts, particularly directing, a basic knowledge of other crafts is essential. But each artist can learn from the other ones. A screenwriter can learn something about writing from listening to the sound in a film, just as a cinematographer needs to have a basic understanding of editing to properly imagine how images will fit together.

There is no better place than film school to gain a basic practical and theoretical background in the other crafts. In film school your time will be limited, but if you structure it properly, you can leave with a much broader knowledge of the entire process, including the other collaborators who directly affect the end result.

9. GIVE YOURSELF TALKDOWNS

Filmmaking is a difficult, exhilarating process that is unique to each individual. As mentioned elsewhere, each filmmaker has her own strengths and weaknesses. While film school will help you identify these, it is up to you to decide how to improve upon them.

After every larger project you complete, be it a screenplay, a short film or something else, take some time to reflect on the process. Feedback is essential to the learning process, and the most important feedback you receive will be your own. You are the only person with a clear window into your consciousness, history and process. It will be up to you to evaluate yourself after each project to see how you can improve.

Here are some questions you can ask yourself to help you get the most out of each project.

1. What did I do well on this project? Why?
2. What did I do poorly? Why?
3. Who would I like to keep working with? Why?
4. Write out, in a handful of sentences, what you did well, what you need to improve on and how you will achieve these goals with your next project.

10. DEVELOP HEALTHY HABITS

Understand that filmmaking is often not a healthy endeavor, mentally or physically. You work long hours, deal with inordinate stress levels and tremendous uncertainty, and are often surrounded by junk food. As a writer, you're trapped at a desk all day in front of a computer. Developing healthy habits could be the difference between a successful career and an early burnout. Here are four essential habits to stave off your physical and mental decline.

1. Exercise Regularly

Exercise is the absolute best method of stress relief available. Instead of reaching for a cigarette, beer or social media when you're stressed out, get

in the habit of going for a workout. The easiest way to begin this habit is to start small: go for short runs or swims and increase the time and distance as you move on. Have a set time every day that you decide to go. If you're particularly prone to anxiety, try coupling exercise with anxiety-provoking activities. As an example, I like to go for a run after I send important emails. Bonus: compared to alcohol, cigarettes or cocaine, a pair of running shoes are relatively inexpensive.

2. Eat Well (Cook)

The Standard American Diet can be damn near suicidal. Processed food, sugar, endless meat, these are a surefire way to feel tired, fat and stressed. Learn to eat whole fruits and vegetables as snacks, avoid any sugary or processed foods and try to eat meat sparingly. The benefits of a good diet are astronomical. Remember, successful filmmakers are like Olympic athletes: their bodies are trained to deal with herculean stress levels.

3. Sleep

In the mid-1990s, K. Anders Ericsson, a Swedish psychologist and researcher, performed a famous study of concert violinists and the factors important to their success. The violinists all listed their amount of practice time as the most important factor in their success. This study became the basis for Malcolm Gladwell's now famous book *Outliers*, which posited that human beings need 10,000 hours of practice to achieve mastery in a field. Practice is no doubt an essential part of achieving mastery, but what Gladwell neglected to mention was what the violinists listed as their second key factor: how much sleep they got.

You'd be surprised how many people in film school destroy themselves and their projects through lack of sleep. The major reason they do so is because of improper time management, lack of self-discipline and taking on too many responsibilities (aka the inability to say no).

Five hours spent working with a full night's sleep can often be as productive as ten hours on an all-nighter. Learn to work when you're rested, and when you've scheduled time to do so, and you will be an infinitely more effective filmmaker. Schedule not only your classes, but the creative time you will use to complete your films and other projects. If you actually do the work during that time, when you're rested, it will make a massive difference for your well-being and the quality of your projects.

4. Meditate

If you're at all interested in filmmaking you're probably also familiar with the massive anxiety that a creative career can produce. Scott Stossel, in his excellent book *My Age of Anxiety: Fear, Hope, Dread and the Search for Peace of Mind*, discusses how human anxiety has its biological roots in the amygdala, an almond-shaped structure in the brain located deep within our temporal lobes. He goes on to cite

> a study published by researchers at Massachusetts General Hospital in 2011, that found that subjects who practiced meditation for an average of just twenty-seven minutes a day over a period of eight weeks produced visible changes in brain structure. Meditation led to decreased density of the amygdala, a physical change that was correlated with subjects' self-reported stress levels—as their amygdalae got less dense, the subjects felt less stressed.

This is probably the most straightforward argument available for daily meditation. Again, as a filmmaker you are going to be facing an onslaught of daily stress, and anything you can do to combat that stress, especially things that cost no money, will work in your favor.

All this can sound a bit intense. What happened to parties with supermodels and powerful hallucinogenic drugs? Again, it's important to develop a sustainable philosophy of filmmaking, and part of that philosophy means being as physically and mentally healthy as possible. If you only have time to write your screenplays on Saturday mornings, and you can't write if you're hungover, then drinking will have to go. It's that simple. Filmmaking is your drug now, and leading a healthy life will offset the relative unhealthiness of pursuing your passion. Consider that if you live a healthy life, you might be able to make films for several decades, as opposed to several years. You will be less prone to the depression and anxiety that plague so many people in film. Finally, pursuing these habits will help you develop the same discipline you need to complete your creative projects.

As a creative person, you are your own instrument; keep it finely tuned.

Build Relationships

It is not from ourselves that we will learn to be better than we are.
Wendell Berry, *Commonplace: The Agrarian Essays of Wendell Berry*

Making a movie is like painting a picture with an army.
John Ford

This chapter is about how to build your army. The second essential part of film school, in addition to the creative portfolio you develop, will be the relationships with classmates, professors and professionals who will advise and aid you on your path from film student to film professional.

A universal complaint about even the most prestigious film schools is that they generally do a poor job preparing their students for the realities of the industry. But an educational institution will always differ from a business. Companies will not hire or work with you just because you went to film school. You have to be the person who builds the relationships that help get your projects made. A school can facilitate connections, but you are the one who has to build relationships. It's a serious responsibility, equal in importance with honing your craft.

This chapter is dedicated exclusively to ways that you can build those relationships while in film school and beyond.

1. DO SEVERAL INTERNSHIPS

Professional internships are an essential part of a film school education. Depending on the company, as an intern you will probably work under an assistant to a producer, executive, agent, manager, director, editor or cinematographer, often doing somewhat menial work. In exchange for your labor, you will be able to see how a film company actually works, as well as potentially make valuable contacts when you graduate and need a job. Spending time with people who make films for a living will also hopefully inculcate a sense of professionalism and a better understanding of how the industry works on a day-to-day basis. Most of these positions, again, are in Los Angeles.

If you embrace your internship as a learning opportunity, leave your ego at the door and complete each task given to you in a timely and professional manner, you will make great connections and increase your skills. There is no better way to learn how people "make it" in the film industry than spending a summer at a major agency or management company, to see how the power brokers in the film industry think, what kind of projects they find valuable and how they spend their days.

As I went through film school, I also realized that even at the intern level there is often a hierarchy of job experience. My best internship, at the

biggest, most powerful company, came in my last year in film school. I applied for this internship twice, the second time with a recommendation from a previous internship.

Even if you don't want to be a manager, agent or producer, time spent in a production company, agency or management company can be a great tutorial in how the industry works. As a young creative, it's also never a bad thing to understand how the people on the other side of the table view you and what concepts like "representation" actually mean.

A good film school will offer opportunities to work at a variety of companies. Start interning early, so you can build a variety of experiences and contacts. If you don't get your top choice company early on, don't lose heart. A little perseverance and networking can go a long way.

2. BE GRATEFUL (ALWAYS THANK AND UPDATE)

> *Gratitude is the sign of noble souls.*
> Aesop

Any successful film career is built on a mountain of favors, personal relationships and goodwill. Throughout your career people will help you with their time, feedback and connections. It is essential that you take the time to thank and update those people, regardless of whether their help gets you where you want to go.

An expression of gratitude is a beautiful thing: a nice thank-you card or email requires no other action from the recipient than to feel good about helping you. Get in the habit now of thanking and updating the people who help you as you continue on your path toward becoming a filmmaker. If you get into film school, write a nice thank-you card to your professors who wrote recommendation letters. Write to the people who read over your essays for you. If someone does something particularly remarkable for you, a handwritten thank-you card and even flowers are sometimes in order. Any personal success is always the result of the people who helped you as well; invite them to feel good about your success, and they will surely want to help you again in the future.

Thank and update people even if you don't succeed. The worst feeling in the world is helping someone, only to never hear from them again; it makes you feel used. Don't be that person. The film world is very small, and the last reputation you want to have is one of ingratitude.

3. LEARN TO MAKE AN EMAIL REQUEST

You will make thousands of requests via email in your life, so now is as good a time as any for some pointers.

1. Have a Clear Subject Line

A reader should have a pretty good idea of what you're asking for if they only read the subject.

2. Keep It Short

Provide only the necessary context for your request. A clean white page is the reader's friend. So is a clean white computer screen. It's inviting, which means that someone might actually read it.

3. Introduce Yourself

If you don't know the person, include information on how you received the contact. If you already know the person, give a brief update on what you've been up to.

4. Always Make a Single, Concrete, Reasonable and Actionable Request

"What does this person want me to do?" If the people reading your emails ask themselves this question, you've lost. It is your job to figure out what you want, then formulate it into a request that the recipient of your email can grant. If you do it well, maybe they'll even feel good about helping you.

5. Thank Them for Their Time and Consideration

The world needs better manners.

6. Revise Important Emails Based on Feedback

Yes, some emails are that important. If you're reaching out to a VIP, they deserve the best possible email you can write.

7. Read Important Emails Out Loud Before You Send Them

There is nothing like reading out loud to catch small errors (like punctuation), and also to force you to really see and hear something you've been over a hundred times already. That applies to all writing.

If your request is important enough to grant, it's worth spending the time to draft a proper email. Not everybody will respond to your requests, but by following these principles you can make sure that it's not because of a poorly written email.

4. YOUR ATTITUDE IS YOUR LIFE

No one, regardless of class, education or background, is entitled to a career in the film industry. As you begin your career, your attitude will be your greatest way to compensate for your lack of experience. If you approach each challenge as if it were beneath you, people will hate you. If you do what is asked with a positive attitude, they will give you greater responsibilities and more knowledge, and perhaps even their respect and friendship.

Be grateful for each day and opportunity, perform each task to the utmost of your abilities, and people will not only want to work with you, you will greatly enjoy life. That attitude and enjoyment will be contagious; people will want to help you because doing so makes them feel good. This is perhaps the greatest skill you can develop before you go into the ring. Why not start now?

5. YOUR CLASSMATES ARE YOUR FILM SCHOOL

The miracle of film school is that you're not going through the learning process alone; there is an entire cohort of filmmakers on the same journey with you. Your classmates will no doubt have some similar influences and make certain choices that are more and less successful. It's important to observe your classmates going through the different processes, as well as yourself.

What do they do well? Not so well? What can you learn from them? How can you help them in turn? Which ones would you like to work with?

Some of the most valuable lessons you learn in film school will not come on your own shoots, or while critiquing your own work, it will come from those of your classmates. Be sure to pay attention to your classmates' choices, philosophies, influences and work habits. Who's good at giving notes? Directing actors? Writing dialogue? Using motion to tell stories? Cutting action scenes? Pitching?

When a piece of work is particularly successful, try and sit down with some of these people for coffee and ask them about their process. This is a surefire way to learn. People are always flattered to share their experiences, and you will have the benefit of their knowledge, which will complement your own.

6. BECOME A TALENT SCOUT

Just as you try to learn from and help your classmates as much as possible, it's also important to be aware of who's good at certain things. As a young filmmaker with little experience and reputation to trade on, you will need to develop a sharp eye for talent. Which cinematographers get striking images? What directors know how to get a performance out of an actor? Who's got the best sound design in their film? Which producer runs the smoothest set? Gives the best notes?

A successful film comes from the work of many people, and the better each of those people are at their respective crafts, the better the overall film is likely to be. Find the people whose taste and voice you admire, and try to collaborate with them.

Sometimes it's important to go outside your comfort zone to try to work with someone you admire. Try to collaborate with the people whose work you respect, and their skills will enrich your work as well. Hopefully you can do the same for them.

Your ability to work with people well, to have and communicate a vision, to be humble and kind, will all help to compensate for your lack of a track record.

7. DON'T COMPARE YOURSELF TO OTHERS

Envy shows how unhappy people are; and their constant attention to what others do and leave undone, how much they are bored.

Seneca

Thanks to the magic of social media, it's now possible to compare an average moment in your life with peak moments in the lives of everyone you've ever met. It's a very easy way to feel awful.

It's important to remember what Hulk wrote in the Introduction, that

THE OLD CLICHÉ OF "A RISING TIDE LIFTS ALL BOATS" HOLDS MORE TRUE FOR THIS INDUSTRY THAN PERHAPS ANY OTHER (THERE ARE A LOT OF JOBS ON A BIG FILM SET, FOLKS).

Even if you don't directly benefit from someone else's success, your school and its brand, which you are a part of, do.

It's also important to remember that every filmmaker is unique; the only person you can directly compete with is yourself. When you feel jealousy of someone else's accomplishment, a good question to ask yourself is:

"What could I be doing right now to improve my project?"

Then get off Facebook and do that thing.

8. (DON'T BE AFRAID TO) FALL IN LOVE

> *Life isn't a support system for art. It's the other way around.*
> Stephen King

When I got to film school, a friend of mine said, "I'm not going to get a girlfriend while I'm here. My girlfriend is cinema." This still bothers me, for one simple reason: cinema is the worst partner imaginable. Cinema takes all your money, leaves you in debt, and fills your inbox with rejection letters.

A human partner in a healthy relationship will be your greatest source of happiness, fulfillment, stability, feedback and solace when your other love borrows a hundred grand from you and tells you that your screenplay is shit.

Building a happy, stable life, including a relationship, will help your filmmaking and keep you motivated through the inevitable hurdles to come. And when that other partner sends you a hundred festival rejections, you'll have someone to talk you off the ledge for the three hundredth time.

9. CHOOSE YOUR COLLABORATORS WISELY

When you enter film school, generally the first collaborators you have are chosen by the school. Quickly thereafter, though, you enter the quagmire of having to decide who to work with. Who you choose to collaborate with and why will be one of the determining factors of your film school education, as well as the success of your films. Here are some foundations for successful collaborations.

1. Body of Work (Talent)

It's important to admire the work of your collaborators. Early on these will often be snippets: a beautifully composed shot in a film, an awesome bit of dialogue, one great costume choice. Whatever that thing is, you need to

appreciate some work that the potential collaborator has done, as well as understand how that that fits into your vision for the project.

2. Vision

As collaborators, it's important early on to have a discussion of what the broad vision is for the piece. This is not only aesthetic but practical. What other films resemble what you're trying to accomplish? You don't want to try to make a small independent film with a cinematographer who thinks they're shooting *Avatar* and vice versa. Work on articulating your vision, and make sure that you and the other person can agree on that vision. You will save yourself endless headaches along the way.

3. Roles

Clearly defined roles help everyone. If you're writing a screenplay with a friend, and both of you want to be directors, are you going to do that together? What will that look like? Answering these questions in advance, before too much work has been done, will be to your advantage.

10. WHO YOU KNOW DOES MATTER (A STRATEGY FOR MEETING PEOPLE)

Opportunities in the film industry are funneled through endless private networks of people. Initially, you will probably not be a part of these networks. The good news? It's completely within your control to join them. But you must start doing it as soon as possible. Treat it with the same seriousness as honing your craft, because it's just as important. As you continue through film school and your internships, figure out who you know in the industry, or who your friends know, and ask if you can buy them coffee and get some advice.

The ideal candidates for this are assistants at agencies, management companies, studios or production companies (again, most are all in Los Angeles): because they have an intimate knowledge of the industry, and because they're also beginning their careers, they'll be more likely to grab coffee with a wide-eyed film student. You'd be surprised how many people in Hollywood are eager to play the role of the all-knowing mentor, so it never hurts to ask.

Make a good impression, but the conversation should be about them, not about you. Be humble, curious and gracious. You can tell them what you're

working on, but mostly just ask them questions. This is an opportunity to learn about them and the industry, not to brag about the script you're writing. That will come later, because this is about playing the long game. No one wants to feel used, so if you ask them to read your script or to pass it along to their boss right away, that will be a huge turn off.

Instead, invest in the relationship. Email them when you spot their name or their boss's name in the trades. Check in with them every once in a while. Grab lunch again at some point. You're building mutually beneficial relationships here, because they need good material from writers as much as you need people to read your scripts. But if you get to know them first, they're much more likely to want to help you when you actually need it.

Craft an Exit Strategy

Ambition means tying your well being to what other people say or do.

Self indulgence means tying it to the things that happen to you. Sanity means tying it to your own actions.

<div style="text-align: right">

Marcus Aurelius, *The Meditations*

</div>

As you continue on through film school, shaping your voice and building your network, you will need to develop an exit strategy. As mentioned, students (particularly graduate students) often spend thousands of extra dollars on tuition (i.e. debt) for the sole purpose of delaying this transition into the real world. In this chapter I'll talk about the transition between film school and real life, and some ways that you can prepare for it.

1. THE LEAN YEARS

> *Lean years follow in the wake of a great war.*
> *Just do what needs to be done.*
> Lao Tzu

If you look at the IMDB profile of many successful filmmakers, you will notice a curious gap. For Alexander Payne it's the five years between *The Passion of Martin*, his UCLA Thesis Film, and *Citizen Ruth*, his first feature film. With screenwriters it's harder to gauge this period, but if we go by the 10,000 hours rule, it is likely very similar.

This five- to seven-year gap, which I call "The Lean Years," is nearly universal for those rare filmmakers who make the transition from shorts to features. Of course some people will get lucky, others will race to complete half-baked projects, and others might actually be geniuses who make a good feature fast. But 99 percent of the filmmakers you know and love had to go through the lean years. Five to seven years is a tough number to chew on, but let's look at an example.

Cary Fukunaga was my film school role model. This was the guy who had it all: a student short at Sundance, followed by a successful feature. But guess how long it was between his excellent short, *Victoria Para Chino*, and *Sin Nombre*, his equally-remarkable first feature? Five years. Not even the once-in-a-decade talents get to skip this part of the process.

If most film students never transition into professional work, this is a big part of why. To guard against The Lean Years we must prepare ourselves for difficulty, not ease.

If you expect your first feature or produced work to take five to seven years, and it takes four, it's a miracle. If you expect it to take six months and it takes five years, you'll feel like a failure. That's enough to make someone quit filmmaking.

Heidi Grant Halverston is a researcher for the Columbia Business School who wrote a remarkable little book called *Nine Things Successful People Do*

Differently. One of the book's main concepts is what she calls being a "realistic optimist." Realistic optimists are people who

> believe they will succeed, but also believe they have to make success happen—through things like effort, careful planning, persistence, and choosing the right strategies. They recognize the need for giving serious thought to how they will deal with obstacles.

This seems like what we filmmakers need. Instead of fantasizing about how the film that will one day be made from our unwritten screenplay will premiere at Sundance, we would maybe do better to ask questions like: How am I going to get this screenplay written? How am I going to get this feature made? What producers would I like to work with? How will I get their attention? What kind of obstacles will I face? What will I do to overcome them?

Again, take an opportunity to write out a list of goals for yourself upon graduation. It's very helpful to break these goals into different time periods. Where do you want to be in five years? Three years? Six months? If you have these goals in mind, it will be easier to filter your day-to-day choices through them, as well as develop strategies for achieving them.

2. FILM FESTIVALS

Film festivals are an essential part of building a young director's career. They can offer young filmmakers validation, the opportunity to network with other filmmakers, the potential access to cash prizes, the ability to see your work on the big screen with an audience and, if it's a top-level festival, excellent resume building and a greater legitimacy for your next project.

The number of festivals in the world can be a bit daunting, so as you build your strategy for your film, it's good to keep a few questions in mind.

1. Where Do You Want to Work?

If you're American and want to work in America, then you're probably going to stick to the major American and world festivals, perhaps with a small emphasis on local festivals where you're from. I'm from Michigan and always work very hard to get my films out to smaller Michigan festivals. I want to keep making films in Michigan, so it's important for me to have a presence there.

2. Why Am I Submitting to (Insert Festival Here)?

Festival submissions can quickly become expensive, so it's important to have a reason to submit to every festival. Again, local film festivals are amazing places, but they should ideally be local to you. If you're not from the United States and your home country has public film funding, very often they have bizarrely idiosyncratic lists of which festivals qualify you for future funding. Look up your nation's film institute to find this list. This applies in particular to Europeans.

3. What's Your Budget?

It's very important to make a budget for festivals and stick to it. It can become very easy to just start firebombing every film festival in the world, to the extreme detriment of your finances. Festivals are very expensive to submit to, particularly in America, so again it's important to have a reason to submit to each individual festival.

There are massive amounts of information on which festivals are important, and this information changes a little bit every year. I will discuss some individual festivals in the next section, but right now I want to discuss a few other, lesser known parts of this process.

4. Premiere Requirements

Festival premiere requirements are slightly different for short films, but it's still important to be aware of them. The different types of premiere requirements are as follows:

a. World Premiere

This is the first time your film has ever screened publicly, anywhere. For most major festivals, this is a currency they trade in. Most major European festivals will require a world or international premiere.

b. International Premiere

This is the first time a film screens outside of its country of origin. If you shot your film in the United States, and it had its world premiere at an American festival, then you still have an international premiere to give. If you shot your film in the United States, and it has its world premiere in China or Switzerland, then you have used up your world and international premieres in one shot.

c. National Premiere

This means the first time a film has played in a specific country. If your film plays in Toronto after already doing a world and international premiere, that will be your Canadian premiere.

d. City Premiere

Many festivals require (or prefer) a film to not have been screened in that individual city. As many major cities, like New York, have multiple prestigious festivals, it's good to remember that many of them have city premiere requirements. If you screen at a smaller festival in a city, you may disqualify yourself from screening at a larger festival in that same city.

5. Keep the Faith

Submitting to festivals can be a grueling process. There will be many days where you open up your emails to find that you've been rejected from some major festival. It's important to understand that rejection is part of the process, and that you only need one yes to have a huge impact on your film's life. Think about it like dating: you don't make out with every person you meet, at least I hope not. It's also important to submit to every festival on your list, even when the rejection letters are pouring in. This is the perseverance I keep mentioning.

If your films get rejected from every festival you submit to, take a day to mourn, then make another film. If you get into some top festivals, pat yourself on the back, then think about how you're going to make your next film. There is no achievement in filmmaking that allows you to hang up your boots and let other people do the work for you, no matter how successful you are.

3. SOME FILM FESTIVALS YOU SHOULD KNOW

Too many filmmakers simply send their films to Cannes or Sundance, then give up when they don't get in; don't be one of these people. Understanding the festival landscape will do wonders for your growth as a filmmaker.

As a young filmmaker, be warned: not all film festivals are created equal. Many festivals prey on young filmmakers' desperate need for acknowledgement. Do your research before you send a film, and be sure to come up with at least one compelling reason to submit to a festival before you shell out anywhere from $35 to $60. Do not apply willy-nilly to every festival

you see and expect it to build a career. A hundred meaningless festivals do not add up to one Sundance or Cannes. I can't discuss every festival in the world, but the festivals listed here are generally considered to be significant.

On a final note, as a book geared toward American audiences, this section is primarily devoted to major European and North American Festivals. Because of this I have omitted several deserving Asian festivals (Busan, Tokyo, Shanghai), as well as some important European festivals (Locarno, Rotterdam, San Sebastian, Karlovy Vary). This is meant to be a primer, not a definitive list. As always, your own research will be necessary to supplement this information.

1. Top Five

a. Cannes

The Cannes Film Festival, the grand poobah of film festivals, takes place every May in southern France. It's not only a film festival but also a major film market, where producers, sales agents and distributors meet in an effort to buy and sell their next projects. For a humorous look at the marketplace, check out James Toback and Alec Baldwin's documentary *Seduced and Abandoned*, wherein we follow their relentless efforts to find a financier for their fake feature film called "Last Tango in Tikrit."

Because Cannes is currently the world's most important film festival, I will go into more depth about its specific sections.

Cannes has four major sections for feature films:

1. Competition

This is the main event, with world premieres of some of the best known filmmakers (often *auteurs*) in the world, who compete for the coveted Palme d'Or, or golden palm. There are several other important prizes, including best director, screenplay, acting and so forth. Many filmmakers make several films before they make it into the Competition section; others get in on their first try and never see it again.

2. Un Certain Regard

French for "a certain look," this is the midlevel section that, again, is extremely prestigious. These are often filmmakers who are in the middle of their careers, as well as those with bolder directorial visions.

3. Director's Fortnight

Known as *Quinzaine des Réalisateurs* in French, Director's Fortnight is an independent parallel section held in Cannes ever year. It was founded in 1969 after the uprisings in May 1968 resulted in a cancellation of the Cannes Film Festival in solidarity with striking workers. Fortnight is generally the youngest section of Cannes, and thus features the most emerging filmmakers. As well as features, Fortnight also features a small selection of short films.

4. Critics Week

Critics Week is another parallel section that is also an important launching pad for feature films. It also takes a small selection of short films, mainly fiction.

Cannes has the following three short film sections:

5. Cinéfondation

The Cinéfondation is an extremely selective section consisting of around 15 student short films from around the world. The section is competitive: the winner receives a guarantee that their first feature film will screen at Cannes, a remarkable opportunity to say the least.

6. Court Métrage

This is the short film competition section, also very small, that often features the short film works of established auteurs alongside up-and-coming filmmakers. Selected filmmakers compete for the Short Film Palme d'Or.

7. Short Film Corner

The Short Film Corner is a marketplace for short films, as well as a program of events for short filmmakers. You can enter the Short Film Corner for a fee. The program offers filmmakers the opportunity to meet and network, including badges that allow access to certain closed areas of the festival, as well as the opportunity to understand more about the industry. Short Film Corner participants' films are screened in a number of private viewing booths and a few small theaters.

As much as filmmakers would like to believe it, having a film at the Short Film Corner *is not* the same as having a film programmed at Cannes. Around

2,000 short filmmakers are invited to participate in the Short Film Corner. By comparison, in 2014 Cinéfondation, Court Métrage and Critics Week combined selected only 35 films.

I don't want to rain on anyone's parade, but the homemade "Cannes Short Film Corner Laurels" are thus mainly a sign that you paid a fee to attend the festival. It is not the same as having a film selected at the festival, so don't expect it to brand your film as such. Seeing "Official Selection: Short Film Corner" on a filmmaker's website or short film cover page is a surefire mark of an amateur.

b. Sundance

Held in Park City, Utah, every January, the Sundance Film Festival is the premiere launchpad for American independent films. For ten wintry days, Park City becomes a zoo of filmmakers, sales agents, journalists, agents and programmers all excited to see the new crop of American films. Despite a changing distribution climate, the Sundance Film Festival is still one of the best unofficial marketplaces for American filmmakers to find distribution for their films, increasingly on a "day and date" basis (simultaneous VOD and theatrical release).

Sundance programs a small group of short films (around 60) in its US Narrative, International Narrative, Documentary Short and Animated Short Film categories, all of which are competitive and award prizes.

Most American filmmakers dream of Sundance, and they have the submissions (over 10,000 shorts and features per year) to prove it. Sundance, however, is not a career lottery. If you look at the resumes of the selected filmmakers, many of them have spent years building their careers through several films, many of which play the festival circuit for years before one of them gets into Sundance. Again, any major filmmaking success, including Sundance, is generally the culmination of years of hard work, rejection and perseverance.

c. Berlin

The Berlin International Film Festival takes place every February in Berlin, Germany. In addition to the festival, which hosts a massive selection of feature and short films from around the world, it is also the home of the European Film Market, where, just like Cannes, thousands of buyers and sellers come together to make deals for the next year's slate of movies.

Berlin programs a huge variety of short films in many sections, including a short film competition, a forum section for more experimental films, the

Teddy awards for queer short films, Generation for youth-oriented short films, and more. It also hosts the Berlinale Talents, a yearly program that selects a small group of young filmmakers to attend the festival, do workshops and network with each other.

There is only one (quite expensive) submission fee for all of the various short film sections, though in the submission process you can check areas (youth, queer) that might demarcate your film for a specific section.

d. Venice

The Venice Film Festival, the oldest continually running film festival in the world, generally runs from late August into early September. With Cannes and Berlin, it is a premiere European launchpad for feature films, including several American awards contenders. Among a host of other prizes, it awards the Golden Lion for best feature film.

Venice screens a small selection of short films (exclusively world premieres) in its Orrizonti section, which awards a Golden Lion for the best short film. It also hosts Biennale College Cinema, a program that finances three micro-budget features each year.

e. Toronto

Also in September every year, the Toronto Film Festival is a major site for American and international awards contenders (read: Oscars) to have their premieres. The festival itself is enormous, with over 300 feature films in a variety of programs every year.

As far as short films go, Toronto traditionally only accepted Canadian short films. That changed in 2014 with the inaugural section of "Short Cuts International," which features short-form work from around the world. It will no doubt become an essential part of the international short film festival circuit.

2. Top American

a. AFI Fest

Every November in Los Angeles, the American Film Institute (AFI) hosts a festival that is an excellent overview of the best films of the year. AFI Fest believes in showcasing the year's best work from both emerging and established directors, and is also an Academy Award qualifying festival for short films. Founded in 1971, it is Los Angeles' longest running international film

festival. Through its partnership with the American Film Market (AFM), AFI Fest connects art and commerce and collectively represents the largest gathering in North America.

b. Los Angeles

Hosted by Film Independent (FIND), a major, Los Angeles-based independent film organization, the Los Angeles Film Festival is a major event for American independent cinema. Hosted in downtown Los Angeles, the festival, like AFI Fest, hosts a series of screenings in the capital of cinema. Its focus is on independent cinema, and it has become a premiere stop on the American festival circuit.

c. New York Film Festival

Hosted by the Film Society of Lincoln Center, the New York Film Festival is one of the oldest and most prestigious film festivals in America. It serves as a home for a handful of world premieres for some of the world's largest filmmakers, but is primarily a brilliantly curated selection of the world's best arthouse cinema. This is where many established international auteurs celebrate their North American premieres after world premieres at Cannes or Venice. It also features several short film sections.

d. Slamdance

Started in 1995 by filmmakers who didn't get into Sundance, Slamdance takes place at the same time and the same place as its older counterpart. Focused primarily on first-time filmmakers, Slamdance has since grown into a respectable site for young American independents to premiere new work. Many of the filmmakers you know and love have premiered their first, scrappy features at Slamdance, and more than a few have sold them there as well.

e. South by Southwest (SXSW)

The SXSW film festival is part of a massive festival that includes music and interactive portions. The festival initially drew attention as the epicenter of the American mumblecore movement, and has since grown from its humble roots into a powerhouse festival featuring some of the best in American independent filmmaking. It is the premiere post-Sundance destination for strong titles that did not get into Sundance, or those that were not ready, as well as select Sundance titles that SXSW deems worthy of additional exposure. It

has also had a few breakout successes, including the world premieres of Lena Dunham's *Tiny Furniture* and Destin Cretton's *Short Term 12*, both of which won Grand Jury Prizes before going on to critical and popular acclaim.

f. Telluride

Held each Labor Day weekend in the mountains of Colorado, Telluride is an exclusive, beloved and extremely well-curated event. With Toronto, Venice and New York, Telluride is also one of the most sought-after destinations to premiere fall, award-hopeful films. It hosts a small lineup of new and classic films, which it never announces until the day before the festival. It has been described by Indiewire as "a summer camp for cinephiles," who pay significant sums to attend a festival that is both difficult to get to and short on low-cost accommodations. This is the festival that's famous for bringing the world's cinema elite to a friendly, low-key location, where you might see Alexander Payne and Werner Herzog outside a theater discussing a film they just saw. Telluride programs a small number of short films in noncompetitive sections. They say that getting into Telluride is like winning a prize, so there's no "Best Short Film" award to be seen here.

g. Tribeca

After the attack on the World Trade Center, Robert de Niro, Jane Rosenthal and Craig Hatkoff created a new film festival in Manhattan. It has quickly grown into one of the most important film events of the year, both in New York and in the larger American and international landscape. At the moment, the festival is known in particular for strong documentary programming, which has showcased films by new voices such as Sean Dunne (*Oxyana)* and Jody Lee Lipes (*Ballet 422*). It also programs a number of short films.

3. Major Documentary Festivals

a. AFI Docs

Formerly known as Silverdocs, AFI Docs is widely considered one of the best documentary festivals in the United States. It consistently screens documentaries that garner both critical and popular acclaim, and that go on to win major awards. The festival is held each June in Washington, DC, and it also hosts the International Documentary Conference, the largest documentary conference in the US. Because of its location in Washington, DC, the festival also creates a unique link between filmmakers, audiences and policy makers.

b. CPH:DOX

Founded a little over a decade ago, CPH:DOX has quickly become a powerhouse showcase for documentary film. Short for Copenhagen International Documentary Festival, it is the largest documentary film festival in Scandinavia. It is interested in developing the documentary genre, as well as inspiring the dialogue between creative forms, and is thus interested in a wide array of media with documentary aspects. It is one of the most exciting and interesting stops on the international documentary circuit.

c. Dok Leipzig

Founded in 1955, Dok Leipzig is one of the world's oldest documentary film festivals. With the Berlinale, Dok Leipzig is also the premiere German film festival, showcasing a variety of work from around the world. It offers not only festival screening opportunities, but also talent development programs for aspiring documentarians.

d. Full Frame Documentary Festival

Held every year in Durham, North Carolina, Full Frame has become an excellent host to some of America's best documentary film. It is held over four days and takes the unique approach of screening each film only once, often at the same time as three or four other films. This creates a sense of urgency among audiences that often leads to sold-out screenings.

e. Hot Docs

This is North America's biggest documentary film festival and conference. The festival hosts several world and North American premieres each spring in Toronto. It also attracts thousands of delegates, including filmmakers, buyers, programmers, commissioning editors, distributors and other power players from the documentary world. In addition to the festival, Hot Docs also runs the Toronto Documentary Forum, the largest documentary market in the world. The festival programs short films both in its own programs and before features.

f. International Documentary Film Festival
Amsterdam (IDFA)

IDFA is the granddaddy of all documentary film festivals, where major international documentaries go to premiere, many of which will make their way through the festival circuit. It attracts thousands of industry insiders

from all over the world, and hosts several talent development programs, a market, as well as a fund that supports documentary filmmakers in developing countries.

g. Sheffield Doc/Fest
Held every June in a small, friendly town in the north of England, Sheffield Doc/Fest has become one of the biggest stops on the international documentary circuit. This includes industry visitors, of which the festival has boasted over 1,200 in recent years. It offers a variety of programs geared to help filmmakers of various experience levels.

h. True/False
Named "one of the most vital film festivals in America" by Indiewire, True/False, held each year in Columbia, Missouri, has built a reputation as one of the most fun festivals in the world. They draw some sizeable, enthusiastic crowds to their large venues, which often feature opening music by indie bands. They also write the nicest rejection letters of any festival in the world, one of many examples of their courtesy, hospitality and respect for filmmakers. Also of note is the annual True Life Fund, a sizeable cash prize sponsored by a local church, which is given to the *subject* of one of the festival's films, perhaps the only prize of its kind.

i. Visions du Réel, Nyon
Visions du Réel is the Swiss home for some of the strongest, and most innovative documentary filmmaking. The festival is open to a variety of interpretations of documentary film, including experimental film, essays, epic and anything else that promotes its mission to be "an explorer, purveyor and promoter of documentary filmmaking . . . it aims to be exploratory above all else."

4. Major Short Film Festivals

a. Clermont Ferrand
Founded in 1981, this is the world's largest and most prestigious shorts-only film festival. In addition to the festival, it also features a large short film market. It is the second largest film festival in France (after Cannes) in terms of audience and professional attendance, and definitely not to be missed.

b. Palm Springs Shortsfest

Founded as an offshoot of the Palm Springs International Film Festival, the Shortsfest has grown into a major festival in its own right. Each year it programs more than 300 short films from over 50 countries, as well as presenting over 3,000 short films to buyers through its market.

c. Aspen Shorts Fest

A yearly celebration of short films in all their forms, Aspen is known as one of the most short-filmmaker–friendly festivals in the world. Like many of the other festivals on this list, it is Oscar qualifying, and brings together audiences passionate about short-form content.

This is but a small glimpse into a large and vibrant world of film festivals. Don't take this list as the end-all-be-all for festivals. There are many other deserving festivals that are not on this list. For more festival resources, you can look at Indiewire's Festival Guide, the Academy qualifying short films list and in the many film publications I mention elsewhere in the book.

4. HOW TO APPLY TO FILM FESTIVALS

So you've gone through and done a lot of research, and now you're finally ready to apply to all those film festivals. How will you keep yourself organized and motivated through all of those applications?

I'm including a spreadsheet template at the end of this book for your personal use. When you're ready to apply to festivals, simply fill in the spreadsheet with all the festivals you've decided to apply to. When you've finished, be sure to sort the list by the early deadlines (the cheapest ones), so that you always know which ones are coming up at any given time.

Then you have to remember to submit and check the deadlines regularly. When I'm submitting a film to a festival, I create a monthly reminder on the 15th to check festival deadlines. Whenever I see a new deadline is opening, I create a reminder on that date to submit.

Festivals, especially European ones, seem to want to have every possible version of your film for screening. Here are a few useful ones to have on standby.

1. DVD

Build a DVD of your film with simple cover art (generally a still) and a large, prominently featured "PLAY" button. It's not necessary to create a

bunch of elaborate DVD cover art (and avoid paper, stick-on labels like the plague). Just buy a blank, grey DVD and a black permanent marker. When you submit to a festival, write the name of your film, the running time, the tracking number (if you receive one) and your name (or the director's name if you're submitting for someone else).

Test the DVD on a real-life DVD player (you'd be amazed how many come out bad), then put it in a paper sleeve with a clear plastic front. Now you have your submission copy. *Do not* include any press kits, images or any sort of marketing materials. They will be thrown away. Festivals get thousands of submissions, and your films should speak for themselves.

2. Online
A password-protected Vimeo link is the second most common way film-makers submit to film festivals. This is definitely a version of your film you should have.

3. A Low-Res Digital File for Uploading
If you keep a copy of the file you made for Vimeo, this is something you can use to upload films to festivals like the Berlin Film Festival that currently have their own servers.

Those three formats should be enough to get you through the lion's share of festival submissions. The most difficult part is keeping the faith and spend-ing the money!

5. HOW TO RELEASE A SHORT FILM ONLINE
After their festival runs, many filmmakers stick their short films in a digital drawer and forget about them. For some films you make, particularly the early, lumpy ones, this is probably not the worst idea. As you start to pro-gress as a filmmaker, however, releasing a short film online can be a great way to continue the life of your film, as well as reach a much larger audience than you can with a festival.

While there are a few places that still pay for short films, usually it's a "we come to you, you don't come to us" kind of deal. Releasing a short film for pay, unless it's had a phenomenal festival run, is also often condemn-ing it to a slow death. The unfortunate reality is that most people are not actively out there looking to pay to watch short films. This is another way of saying that you will most likely be releasing your short film online for no money.

At this point many filmmakers simply unlock the link to their film, or upload it on YouTube. Then they sit, scratching their heads about why they haven't been "discovered" online.

The reality is, that releasing a short film online is a lot of work. You will need to put your marketing hat on to figure out:

1. Who might be interested in seeing your short film (the audience).
2. Where they go and how to reach them (the delivery).

There are a handful of places that focus on releasing short films online.

1. Short of the Week

(Full Disclosure: I have written for Short of the Week for several years, and also had a film featured by them.)

Short of the Week has become the online destination par excellence for online short film releases. Both the (mainly American) film industry and audiences visit the site to find high-quality short-form content. Short of the Week has open submissions for a fee ($29), and can often be a great way to gain exposure for films that might not have received the festival love they deserved. Regardless of whether they're selected, all films currently receive a timely response, and feedback on the films themselves.

2. Vimeo Staff Picks

The circular Staff Picks logo, seen in the upper left corner of many online videos, is becoming its own mark of excellence, on par with many festival laurels. Staff Picks curates from the many different videos available on the site, and can often bring a large number of views to the videos it "picks."

There are no open submissions for Staff Picks, but Vimeo staff are very present at film festivals, as well as constantly searching the site for new content.

3. YouTube

While YouTube definitely has a larger audience than Vimeo, that audience is also a little more "Wild West." If you look at the comments on any given YouTube video, you are likely to see a diverse sample of the most horrific thoughts humankind has ever generated. That being said, there are many opportunities on YouTube to partner with different channels to release your short film. A good way to begin this is to search for

different channels by the genre that matches your film, such as comedy, horror, etc.

4. Media That Covers Issues Related to Your Film

If your film is a documentary, or deals with a specific social issue, an online release can be a great opportunity to target media and organizations that relate to your film's themes. Do a brainstorming session to come up with ideas of audiences that might be drawn to your film, then identify key media that those audiences read. Reach out to the sites themselves or to affiliated journalists with a well-written query letter to see if they might be interested in covering your film.

If your film does not have a baked-in audience like many social issue documentaries, see if there are places that are into the genre of your film. Comedy and horror, for example, both have dedicated audiences and fan sites. Those might be places to reach out to when planning your online release.

Remember, nothing comes from nothing. A carefully planned release strategy can result in a lot of attention for your project and possibly your next one (which you of course have prepared already). Take the time to really consider how to launch your film online, and it will have an exponentially greater impact than if you just throw it up somewhere and expect people to find it.

6. SCREENWRITING OPPORTUNITIES

Like film festivals, the world is filled with screenplay competitions. John August, the screenwriter of movies like *Go*, *Big Fish*, and *Charlie and the Chocolate Factory*, runs an excellent blog and podcast on the world of screenwriting. In responding to a reader's question, August writes that many emerging screenwriters view these competitions as "a sort of become-a-screenwriter" lotteries. Competitions will never be a substitute for building a strong professional network or having a film produced. That being said, four major places where emerging screenwriters can get noticed are:

1. The Nicholl Fellowship

The Nicholl Fellowship is the world's largest and most prestigious screenwriting competition. The competition is specifically designed for emerging writers who have not earned more than $25,000 writing fictional work for film and television, and has an open submission policy. Up to five winners receive $35,000 to complete at least one original feature during the

fellowship year. Even people who are selected as quarter and semifinalists are carefully tracked by the industry. This competition is thus an excellent way to gain recognition as a screenwriter. Know, however, that the competition is fierce: in 2014 they received over 7,500 entries.

2. The Black List

The Black List was started by Franklin Leonard, a Hollywood executive, as a way to bring attention to the best unproduced screenplays in Hollywood. Every year around 500 studio executives, production companies and financiers are asked to weigh in on their favorite reads. It's important to understand that the scripts that end up on this list are already making their way through the Hollywood development rounds; most of the writers already have representation and significant industry contacts. This is thus not a place for beginners without a network. There are, however, several former film students who have gained significant exposure through inclusion on this list, and it's something for young screenwriters to be aware of.

3. The Sundance Screenwriters Lab

Run by the Sundance Institute, the Sundance Screenwriters Lab is a five-day workshop that gives independent screenwriters the opportunity to work on their feature film scripts with the support of established writers. The January Screenwriters Lab, which is held just before the Sundance Film Festival, is the only lab with an open application.

4. The Austin Film Festival's Screenplay Competition

One of the most respected and prestigious writing contests in the country, Austin is usually listed, along with the Nicholl Fellowship, as one of the only screenplay competitions that can attract industry attention.

Understand that all of these competitions are fiercely competitive, and that many of the selected writers resubmit multiple times before they reach the final rounds.

Remember also that, as August writes, a screenwriting competition is not a career lottery. There is no substitute for living in Los Angeles and building a network while developing your craft, whether you go to film school or not. A competition can open a door, but it will not build you a house you can live in; that's on you.

7. IMPOSTOR SYNDROME

After so many years of struggling as a filmmaker, when you do get that first bit of validation, you can often feel like a fraud. I remember clearly when my Thesis Film screened at the South by Southwest Film Festival (SXSW), I was convinced that at any moment someone would walk out onto the stage, point at me and say, "What's he doing here?" I would then be led off the stage by a random assortment of high school bullies, after which I would weep in the parking lot, then move back to Michigan and raise pigs for the rest of my life.

All kidding aside, the first real validation you receive as a filmmaker can be an upheaval. By the time I got into my first big festival, I'd already been rejected by over 30 festivals with the same film. Again, this is called perseverance.

At SXSW I explained my paranoia to a filmmaker friend, who told me about impostor syndrome. Impostor syndrome is a condition where people are unable to internalize their accomplishments. Despite all proof to the contrary, they insist that any success they achieve is due to luck and not to their own efforts.

The saddest thing imaginable is not to be able to appreciate the payoff of your own hard work. A moment may come where you have your first small success, but find yourself unable to enjoy it. Remember the impostor syndrome, take a deep breath and take a moment to celebrate. This is what all the years of hard work are for.

On a related note, after you pat yourself on the back, stay humble. No one is ever as bad, or good, as they think they are.

8. TV WRITING OPPORTUNITIES

Aside from the grueling world of internships and assistantships (which cannot and should not be avoided), there are a number of programs designed to help young writers hone their craft, find mentors, build their network and even get a job writing for television.

Keep in mind that these programs are generally not for novice writers, and that it takes many people several tries before they're accepted. Also bear in mind the caveat that a program is not a career, though these programs can certainly help. Many of the writers accepted into these programs are already in the middle of their careers, have written polished spec scripts, completed film school and built strong contacts who can write stellar recommendation letters for them.

On a final note, several of these programs are designed to combat the rampant lack of diversity in the television industry, so if you're from a minority background, this can be an especially strong opportunity.

Also be aware that, like so many opportunities in the world of entertainment, these programs come and go. Please check online for current program information and deadlines.

All that being said, here are six excellent writers programs to help you on your way.

1. CBS Writers Mentoring Program

The focus of this six-month program is to open doors into the television industry for diverse writers. It offers writers the opportunity to build relationships with network executives and showrunners, supports them in their efforts to improve their craft and helps them develop the interpersonal skills necessary to break in and succeed. Writers are paired with two mentors: a CBS network or studio executive, as well as a senior level writer on a current CBS drama or comedy series. Applications are accepted on a yearly basis between March 3rd and May 1st.

2. Disney/ABC TV Writing Program

Writers accepted into Disney/ABC's prestigious writing program are paid a weekly salary plus benefits. The primary goal for program writers is to work on a Disney/ABC TV series as a staff writer, though staffing is not guaranteed. The program also offers access to executives, producers and literary representatives to facilitate relationships that can help each writer's career. The submission period opens during the month of May.

3. Fox Writers Intensive

This is a highly selective writer's initiative held at Fox Studios in Los Angeles from January to May. It is designed to introduce experienced and diverse writers with unique voices to a wide range of fox showrunners, writers, directors, screenwriters and creative executives. Selected writers work with these individuals in a series of master classes to build on their writing and business expertise. As the web page states: "While employment cannot be guaranteed, every aspect of the initiative is designed with a goal—to provide the accepted finalists with intensive creative and professional development, exposure and opportunity that would best equip him or her to succeed at Fox." Submissions open in mid-September and close in early October.

4. NBC/Universal Writers on the Verge

Writers on the Verge is a 12-week program designed to polish writers' work and ready them for a staff writer position on a television series. This is specifically designed for writers who are "almost there" but need a final bit of preparation with their writing and personal presentation skills. They particularly encourage writers of diverse backgrounds to apply. The program consists of two night classes held weekly at NBC Universal in Universal City, California, where writers focus on creating an exceptional spec and pilot script. The submission period is in May.

5. Nickelodeon Writing Fellowship

This program is designed to attract, develop and staff writers with diverse backgrounds and experiences on Nickelodeon Network Productions. It provides a salaried position for up to one year and offers hands-on experience writing spec scripts and pitching story ideas in both live action and animated television. Its three-phased structure also offers writers the chance to build relationships with creators, network executives, line producers, head writers, showrunners, and story editors. Submission period runs from early January to late February.

6. Warner Bros. (WB) Writers' Workshop

Founded over 30 years ago, the Warner Bros. Television Writers' Workshop boasts a long list of successful graduates, who write for shows including *Boardwalk Empire* and *Desperate Housewives*. Each year it selects 10 writers from almost 2,000 submissions and exposes them to Warner TV's top writers and executives, all with the goal of getting them a staff position on a Warner Bros. produced television show. Submissions open in May.

9. MAJOR INDEPENDENT FILM ORGANIZATIONS

There are many great organizations that support independent film, and by that token, young filmmakers, including writers, directors and producers. I encourage you to look into the opportunities offered by the four major American independent film organizations.

1. Sundance Institute

The Sundance Institute is the oldest and most prestigious independent film organization in the United States. In addition to running the Sundance

Film Festival, they run a series of artist programs, the most famous of which is the Screenwriters Lab. The Screenwriters Lab invites a small group of emerging writers to the Sundance Institute each year, where they do intensive workshop sessions with industry mentors. The Sundance Institute also offers programs for producers, directors, composers, new media artists, documentary filmmakers and more.

2. Independent Film Project (IFP)

Based in New York, IFP guides storytellers through the process of making and distributing their work. It also offers creative, technological and business support through year-round programming, which includes *Filmmaker Magazine*, Independent Film Week, Envision, the Gotham Independent Film Awards, and the Independent Filmmaker Labs. IFP offers a variety of programs for feature narrative and documentary filmmakers, as well as creators of web series.

3. Film Independent (FIND)

Based in Los Angeles, FIND is an independent film organization responsible for the Independent Spirit Awards and the Los Angeles Film Festival. FIND offers a variety of talent development and diversity programs geared toward emerging screenwriters, directors and producers.

4. Tribeca Film Institute (TFI)

The Tribeca Film Institute is a nonprofit organization for filmmakers that also runs the Tribeca Film Festival. Tribeca runs a series of grants, diversity and talent development programs for filmmakers working in documentary, fiction and new media.

As you move toward your first feature, documentary, new media, web series or other major project, one of these organizations may offer you support, validation and mentorship along the way. It's important to remember, though, that a blessing from one of these organizations is not essential to making a film. There is a form of neurosis where filmmakers get fixated on getting into a lab or talent program, as opposed to trying to make the actual film.

Ultimately, you are the person who will greenlight your first major project out of film school, by having a quality script that is cheap enough to actually make, by having a network of collaborators who can help you realize

your vision, and through a body of work that proves you're able to deliver to talent and funders.

5. AFI Directing Workshop for Women

The AFI Directing Workshop for Women is a unique opportunity for female directors with at least three years of professional experience in the arts. The workshop is dedicated to increasing the number of women working professionally in screen directing. As part of the workshop each participant receives extensive mentoring as they complete a short film. The workshop is tuition free, though participants are required to raise their own funds for their projects. Pippa Bianco's short film *Share*, completed during the 2014 workshop, premiered at SXSW 2015 and won the 2015 Cannes Cinéfondation competition. For more info, and application instructions, please visit the website.

10. A CAREER IS NOT A CONTEST

I've mentioned elsewhere in this book that careers are built, not won. Look at the last ten years and you will see that every major writing lab and fellowship have their fair share of unproduced projects and winning filmmakers whose careers have yet to be launched. More important than any fellowship or contest will be the quality of your work and your network. The vast majority of working filmmakers do not enter the industry solely because of some contest, though for some people it helps.

On a second note, with the advent of the Internet, and particularly social media, there seems to be a proliferation of filmmaking contests. You may have encountered them at this point: filmmakers are asked to submit pitches or even finished films in the hopes of winning some prize. In order to win, however, they have to hit up their social networks to collect as many votes as possible from their friends and family.

Some of these contests are more legitimate than others, especially when sponsored by major brands. For some filmmakers, particularly those who want to work in commercials, these can be opportunities to create a spec commercial, and perhaps even gain some exposure for it. Understand, however, that these programs are designed to use you, the filmmaker, to market their brand through social media in exchange for votes and prizes.

So always remember: film careers are built, not won.

11. PRODUCERS

If you're not a producer yourself, this can be one of the most important relationships you form in film school and beyond. As you move through the filmmaking world, always keep an eye out for young producing talent. Always check references, and if someone gets a glowing review from a filmmaker, hang on to them as best you can. Where do you meet producers, or as a producer, where do you meet writers and directors?

1. Referrals

This is that professional network I talked about. Ask your friends if there's anyone they would recommend you work with. As you are probably not super-experienced yourself, sometimes someone who's less experienced but has a great attitude and work ethic can be the perfect fit.

2. Festivals

Traveling to festivals can be expensive and exhausting, but, especially if you have a film playing, it is one of the absolute best ways to meet people. After the years of struggle, filmmakers finally get to see the fruits of their efforts, and the atmosphere is often quite convivial. Remember that the film world is small, and that you can always get a referral from somebody else if you don't meet a producer there.

3. Their Work

Keep constantly aware of the new, awesome short and low-budget feature films that are being produced. Oftentimes the creative forces behind them are now easier to contact than ever. Try reaching out to see if you two might have something in common.

12. CO-PRODUCTION MARKETS

There are several major co-production markets in the world, where producers, sales agents, distributors, television companies and many more get together to buy and sell movies. Like many other things in this chapter, these kinds of events are often things you do after film school, when you've made significant progress on a project, to the point of attaching cast, crew and financiers. Oftentimes the filmmakers who make real headway at these markets are in the process of making their second or third feature. Most of these markets have a rigorous application process, which may require that a percentage of financing is already locked in before filmmakers can apply.

1. Rotterdam Cinemart

Held in late January, Rotterdam is the first co-production market of its kind. It allows filmmakers to present their ideas to the international film industry in the hopes of getting their projects financed. It chooses about 25 new projects in need of additional financing each year. The deadline for project submission is September 1st.

2. IFP No Borders

No Borders is the premiere American co-production market for narrative projects. It focuses on the discovery of 45 new projects in development represented by established producers. It is open to established American and international producers with 20 percent financing in place. Once selected, producers are provided with professional pitching and industry consultation prior to participation. Throughout the week participants take part in one-on-one meetings with top industry leaders, including financiers, distributors, US and international sales agents and top festival programmers. Submission deadlines are in mid/late May.

3. European Film Market (EFM) at the Berlin Film Festival

The EFM runs for nine days in parallel with the Berlin Film Festival every February. This is a massive event where producers, distributors, buyers and sales agents come together to negotiate the sales of a massive variety of films. It includes a variety of specialized sections, including ones for American independent films, documentaries and participants in the Berlinale Talents program for emerging filmmakers. Project submissions open in November and close in December.

4. The American Film Market (AFM)

Held every fall in Santa Monica, the American Film Market is one of the largest film markets in the world, which brings together the industry in all its capacities. It is a massive and overwhelming event where, just like the other markets, producers, directors and writers come to hawk their wares.

5. Cannes Film Market (Marché du Film)

Part of the global capitalist zoo, Cannes' Marché du Film is one of the world's great film markets and definitely among the largest. While it may not be the

first achievement to list in your resume, for the curious filmmaker the Short Film Corner can offer a toe-in-the-water look at this massive event on the Riviera each May. The Marché du Film also offers a variety of networking events and workshops.

13. REPRESENTATION

The biggest question every young filmmaker asks is, "How do I get an Agent or a Manager?" This is seen as a major status symbol and a necessity to having a successful career. For many people there is also the false belief that talent agencies are employment agencies. Hollywood agents are more like real estate agents: they sell "properties," industry lingo for screenplays, television pilots, pitches and so forth. If you do not have something for them to sell, like a completed feature film or screenplay, a solid pitch or a strong cinematographer's reel and track record, there's not a lot for them to do for you.

Time spent worrying about acquiring representation would be much better spent creating work that attracts attention. Generally speaking, agents and managers find you, usually through an accomplishment like winning an award, playing a major festival or a strong referral. The real focus early on should be on creating great work, then finding exposure for that work. As Howard Suber puts it in his *Letters to Young Filmmakers*, his essential survey of the major questions young filmmakers have about the industry:

> An agent doesn't just find you work, you must first provide solid evidence of valuable creative talent that someone is willing to pay for.

This could be a feature screenplay, television pilot, a spectacular short film, a feature film, a web series or another piece of creative work. But imagine if you had to sell yourself to a studio: What accomplishment of yours would get them excited? If you don't have an answer to this question, your time will be much better spent coming up with one.

The second most important way that people get representation is through referrals, as in people who know agents or have agents and are willing to show them your work. These contacts generally come from working for several years in the film industry, which may or may not include film school.

On a final note: agents and managers often get a bad rap from young filmmakers, usually those unable to gain industry attention with their

work. The reality is that the best agents and managers are generally some of the hardest working, most intelligent people working in Hollywood. Of course there are bad apples, but many of the film and television careers you admire were shaped and aided by the hands of a good agent or manager. These people rarely receive any credit from the broader public, but as someone who wants to work in the film industry, they do deserve your courtesy and respect.

14. GET A JOB

This is one of the most terrifying moments for film school grads: How am I going to feed myself and my hungry new debt baby? While this book can't give you a specific company to apply to, these are the four main ways film school graduates earn a living after graduation.

1. Teaching

A professor I know once cynically called film school a Ponzi scheme: "You get into it, get into debt, then you get yourself out of debt by pulling others into it." I dislike this view of education, but there is some truth in it.

One of the first marketable skills you will have upon leaving film school, if you have an MFA, is the ability to teach others filmmaking. Freelance teaching at film schools also often pays decently, and allows you time on the side to work on your own creative projects. The danger can be in becoming a full-time teacher and losing focus on your own work. It will be on you to keep the faith, and keep chugging away at your creative projects on the side.

2. Assistant Work

Especially in Los Angeles, there is an entire army of assistant jobs, working for producers, directors, actors, executives and so on. These positions are difficult to get, but certainly not impossible, particularly if you've done a great job as an intern and developed a solid network. Assistant work is a great apprenticeship in the industry, but the hours are usually very intense and can leave you little time for your own creative work.

The other paradox of assistant work is that there is a difference between "working in the industry" and "making creative work." As an assistant, you will be known as an assistant, and, because of the long hours, it will often be difficult for you to continue to develop your creative skills. These jobs are very 9 to 6 (and often go much, much later).

3. Freelance Work

Freelance work very often consists of shooting projects for clients, working on other people's shoots, editing projects, doing a rewrite for someone and other filmmaking work. Again, nearly all of these jobs will come through referrals in your network. As you prepare to go out into the world, it's very good to develop a particular, non-writing/directing-related skill that you can perform for other people. If you're a cinematographer, this might be working as a gaffer or assistant camera while you continue to shoot your creative projects on the side. As an editor, this very often means working as an assistant editor. Pick a role in film school that you feel you could do well enough to get paid, and market yourself to your classmates and their related networks.

The downsides to freelance work, particularly working on film shoots, are long hours and uncertainty as to when and how long you will be working.

4. Non-Film Related Work

For some film graduates, the only work they can find is outside the film industry. Sometimes this can be a great solution: the pay is better, the hours are more regular and you're not using up all your creative juices reading every awful screenplay Los Angeles can generate. The other advantage of non-film work is there's no way you can lie to yourself that what you're doing is filmmaking. What's important here is to use all of your non-work time to continue to develop your projects and network. Start a writers group, make short films on the side, submit them to festivals, apply to talent development programs and keep the faith.

One of the best strategies can be a combination of several of these, for example doing both freelance teaching and working on freelance jobs, which provide both stability and flexible time to dedicate to your creative pursuits. There is a great deal of insecurity in not knowing where the next job will come from, but the challenge and variety it provides can also be one of the great pleasures of a creative life.

15. GET IT IN WRITING

As you progress along your filmmaking career, eventually you will start to form long-term collaborations. I am not an attorney, and this chapter should not be considered a replacement for one. That being said, some of the most common creative agreements on feature films are made between:

1. A writer and a director
2. A writer and a producer

3. Two writers
4. A director and a producer

As you start to embark on longer projects beyond or outside of film school, a point will come up where it's important to talk with your collaborators about your long-term goals for the project, as well as to formalize your relationships through a written contract.

Contracts are not just important from a legal standpoint; obviously you want to be protected and understand that you own some of the rights to your work, but negotiating a contract with a collaborator is also a way of planning for and understanding the future of a creative project.

Building a contract that both parties agree to forces you to articulate what you want and expect from a creative collaboration. It's an excellent time to really hear each other out, and to talk about long-term goals and vision for the project. Very often, one of you will have an expectation that the other one had no idea about. The best time to have these discussions is somewhat early in the process, before a ton of work is on the table and the stakes are inherently higher.

Some things you can discuss in your initial meetings:

1. What are our goals for this project? Are they compatible?
2. How long will it realistically take? (then add some time)
3. What is our ideal outcome for this project?
4. What are our personal strengths and weaknesses?

As you shape your vision for the project, it's also good to start building the legal framework for it. Here are some major points that every basic contract should address:

1. Ownership: How do profits and ownership break out, in clear percentages? What rights does each party own?
2. Credits: Who gets what credit on the film?
3. Term: How long does the agreement last?
4. Dispute: How will a dispute between the parties be dealt with?

It's important to understand that every relationship is unique; it's very easy to chill the waters by bringing in the legal stuff too early. However, if the collaboration is serious, both parties will be reassured by the presence of a written contract. Go out and celebrate with your partner after signing; it's often a major step in a creative collaboration.

16. CROWDFUNDING

Kickstarter, Indiegogo, Seed&Spark and others have become a new go-to platform for film fundraising. Filmmakers now flock to these sites to hit up friends, family and people on the Internet for funds for their upcoming projects. At some point in your early career, you will most likely at least consider a crowdfunding campaign for one of your films.

I have both conducted and managed several successful crowdfunding campaigns, as well as contributed my fair share. This is not a book on marketing, so I will only include some basic concepts here. If you're interested in marketing and self-distribution, I recommend Jon Reiss' *Think Outside the Box Office*, which will go much more in-depth into many of these subjects.

Here are a few basic thoughts on the process.

1. Save Crowdfunding for a Later Project When You're More Experienced

It's often best to privately finance your very small, initial projects. Your first films should be dirt cheap, commensurate with your level of experience. This is important, because crowdfunding sites never allow you to delete a campaign. Kickstarter, at the time of this writing, will not allow you to delete your fundraising video either.

It's a simple fact that you can only go out to your friends and family so many times before they get fatigued. It's thus best to reach out to your friends and family when you have the project you're best able to make. This is usually a thesis film: at this point, you've not only gotten into film school, but also made several films and learned from that experience. You are at your maximum experience level, and with the resources of your school behind you, have a good shot at making something of quality.

2. Do Your Research

This means finding comparable projects, both successful and unsuccessful, and studying them deeply. What is good about them? Not so good? What goal did they set? Was that goal realistic?

The easiest way to understand how these sites work is to spend some time on them looking at different projects. Contribute to some of your classmates' or friends' work. What feels good to you? Not so good?

Be sure to spend a lot of time on these sites, and to find comparable projects in terms of goal, creator's experience and story. This will serve as a model for you when you shape your own campaign.

3. Identify Potential Audiences for Your Film

There are generally three kinds of audiences.

a. *Primary*

These are the people that your film will most directly speak to and thus those most likely to donate. If your film is about American high school football, for example, this might include current players, coaches, parents associations and fans. A good place to start might be your own high school, or media groups that focus on this exclusively.

The other primary audience for student films are, realistically, your friends and family. These are the people who are most likely to back an unproven, novice filmmaker. They're pledging to support you and your dream of becoming a filmmaker more than your project, and they should not be underestimated.

b. *Secondary*

These are people who are not in your primary group, but who often visit the same media as your primary audience. These could be college football players or alumni, their parents and fans, as well as fans of football in general. Again, a short film is unlikely, without the presence of a well-known star, to generate massive donations from strangers (sorry), so don't necessarily plan on the whole NCAA backing your project. Perhaps you have some personal connections to an alumni association or your school's football program. Again, sports are a simple example; some other films, like comedies, might take a little more digging.

c. *Tertiary*

These are people who might only have a passing interest in your project, but who might be affected by the film's message and so on. For our imaginary high school football project, these might be sports fans in general.

After spending a fair amount of time looking at comparable projects, as well as identifying audiences for your film, you should start to get an idea of what a realistic goal would be.

3. Identify Where Those Audiences Are and How They Get Their Information

After you've identified the audiences for your film, you need to identify where those people get their information. Are there blogs, magazines or websites that they read regularly? How are they going to find out about your film?

The next question to address is, of course, how likely are you going to get coverage for your project on those sites? Remember, the larger your goal, the more impressions your project is going to need to generate in order to reach that goal. Your own social media network is probably not large enough to raise more than a few thousand dollars, so take this into careful consideration.

4. Set a Realistic Goal Based on That Research

After going through all of the potential backers for your project, try and formulate a realistic goal for your project. One way to do this is to take the average donation, then multiply it by the number of people you would need to reach in order to realize your goal.

A lot of this number will be intuition based on your research, personal experience and social network. At this point, I would encourage you to push yourself a little beyond the most realistic estimate, maybe 10 to 15 percent. If you think you can raise $5,000, try for $6,000. This will push you in the difficult days ahead. Hopefully you can exceed your own expectations.

5. Crowdfunding Is a Full-Time Job: Prepare Accordingly

Many, many filmmakers launch their campaign, post it on Facebook, then wait for the money to come rolling in. This simply doesn't happen. Read any of the thousands of articles written on crowdfunding at this point, and they will all say the same thing: it takes a lot of time and effort to raise money, on par with working a full-time job. Plan to be free to write emails, social media posts and press releases for a good chunk of the time you're campaigning; if you want to be successful, it will certainly demand it.

6. Make a Calendar for the Length of Your Campaign

Plot out the events you will host, press coverage you will receive, backer updates, social media updates and any other marketing you will do over the course of your campaign. Make sure you plan plenty for the middle or slump period of the campaign. Know that statistically the greatest group of backers come at the end of a campaign, when the pressure is the highest to succeed. Do not, however, expect the last three days of your campaign to provide all the momentum you will need to reach your goal.

On your calendar, write out goals for where you would like to be in terms of the amount you have raised by that point. Track yourself against this, again

with the understanding that there is generally a surge toward the end of the campaign, often up to 30 percent.

7. Invest Time (and Maybe a Little Money) in the Video
The easiest way to kill a campaign is a crap video. Spend some time studying other videos, and come up with a simple, short concept for yours. It is often worth investing a little bit of money in decent equipment and a crew to put together a professional-quality video. You're asking for people's money, and you want to look like you know what you're doing.

8. Invest Time in the Rewards (and Price Them Fairly)
Crowdfunding is like a form of pre-sales combined with a charity fundraiser. Your rewards will probably be related to the world of the film. To use our American football example, perhaps people can get free tickets to a game at higher reward amounts, or get an autographed football for another. At the lower levels, you will likely be offering things like t-shirts and a copy of the film.

You can offer items like a copy of the film for a little bit more money than you would expect to pay, but don't go crazy. When I see $25 for a download of a short film it always feels a bit extreme to me. This is a disadvantage, because when I or others contribute for the lower-end rewards, what we often want is a copy of the film itself. If the download or DVD is a little more expensive than a backer is willing to pay, they will probably cough up a little more money, say $5 or $10, to get the better reward. But if it's double the price they're willing to pay, they will probably stay at the lower reward level.

Again, the best ways to gauge the amount and level of rewards is by studying other campaigns and following your intuition.

9. Budget for the Cost of Rewards
Remember that every reward you offer will have to be designed, created and shipped. This can be a significant cost, which will cut down the amount that you actually raise, so be sure to budget for it, just like you budget for the film.

10. The Crowdfunding Site's Percentage
Depending on the site, and whether you meet your goal, you will be paying around 10 percent of whatever you raise. Keep this in mind as you set your goal.

This is a lot to think about, but there's no such thing as free money, even in the magical utopia of the Internet.

17. PATIENCE (REJECTION)

There's a way that the force of disappointment can be alchemized into something that will paradoxically renew you.
Martin Scorcese

After a particularly crushing series of festival rejections, a friend told me once, plainly, "We get rejected for a living."

This is important to remember. As you go through the endless rounds of meetings, rewrites, submissions and applications, understand that rejection is an absolutely common and essential part of the process.

If you choose to enter a career in film, you will face massive rejection, no matter how successful you are. You just have to pick yourself up and keep working. Remember, filmmaking is not an act of genius, it's an act of sheer will.

When you face a major rejection, there are two ways you can go with it: you can see it as a personal attack (which it never is), or you can see it as an opportunity to work harder, to restrategize and to make your project better. A powerful "no" can often be the impetus that finally pushes a filmmaker to take the steps that get a film made. The worst part of the process is not the rejection, it's the waiting for rejection.

Dealing with rejection is simply the filmmaker's lot. If you can use the force of disappointment as fuel for you to make the best work possible and to get out there and bang on every door, then you've won. You are the person who decides whether rejection will end your filmmaking career, or whether you'll change your strategy and persevere.

18. LEVELING UP (LEARN TO LOVE THE PROCESS)

In *A Guide to the Good Life*, William B. Irvine's excellent guide to Stoic philosophy, he discusses the concept of "hedonic adaptation," which he describes like this:

> We human beings are unhappy in large part because we are insatiable; after working hard to get what we want, we routinely

lose interest in the object of our desire. Rather than feeling
satisfied, we feel a bit bored, and in response to this boredom, we
go on to form new, even grander desires.

To counter this nefarious predilection of ours, the Stoic philosophers believed that the best way to be happy in life is to learn to want the things we already have. One way to do this is to keep a gratitude journal, wherein every night you reflect on the blessings you've been given in life. If you learn the habit of gratitude, not only to other people, but for the daily accomplishments of writing a scene, submitting your projects, incorporating feedback and so on, you may stand a chance of actually being happy.

As you move through your career as a filmmaker it's important to learn to derive your pleasure from the process of making creative work. If you only base your happiness on major events like festival premieres, selling a screenplay or a new job, you will be setting yourself up for a life of misery. These events are often outside our control and only come rarely.

If you continue to do the hard work of creating, revising and submitting, as well as building your professional network, you will slowly work your way up the ranks. I have a dear cinematographer friend who calls this "leveling up." Her first level up came when she shot her first feature film, her second one came when another feature film she shot screened at a major festival, and her third level up came when she was able to purchase a home in Los Angeles based solely on her income from cinematography (now that's a hell of an achievement).

These levels usually take several years in between, and if they are the sole source of your happiness, they will not be enough to sustain you. Learn to appreciate the small triumphs in the day. If you reflect on them often, you may have a chance at real happiness in this crazy filmmaking world.

19. ALWAYS MAKE THE HARD CHOICE

> *Rule of thumb: The more important a call or action is to our soul's*
> *evolution, the more Resistance we feel toward pursuing it.*
> Steven Pressfield, *The War of Art*

There can be no real success in life without risk. What you will learn daily is that rejection, failure and sacrifice are just as essential. There can be no growth without loss: of illusions, bad habits, even unhealthy relationships. Don't fear loss or change. Fear inertia, fear a lack of fulfillment, fear

repetition. Fear procrastination and perfectionism, the twin demons of creative work.

As you continue on this path, always favor the difficult and the uncomfortable over the facile and reassuring. If you keep to the difficult path, following your inner voice, persevering to get your projects made, you will one day realize, Wow, I'm a filmmaker. And that is something no one can take away from you.

Life After Film School: A Benediction

The growth of a frail flower in a path up
has sometimes shattered and split a rock.
A tough will counts. So does desire.
So does a soft rich wanting.
Without rich wanting nothing arrives.

Carl Sandburg, *Harvest Poems*

In this book I have done my best to paint an honest portrait of the highs and lows of film school and life as a young filmmaker, based on my short experience thereof.

I want to close with a bit of motivation, a reason why we perhaps go through all of this craziness:

> there is no greater pleasure in life than a hard-fought, earned success.

After going through years of disappointment and confusion, to finally make something that connects with people is indescribable; it both melts away all the years of hard work and immediately makes you hungry to do it again.

I wish for you to one day have that same feeling. In order to get there, I also wish you

> The Discipline to create your work,
> The Courage to put it into the world, and
> The Perseverance to overcome the inevitable rejection, criticism and indifference along the way.

Enjoy the ride. I'll look forward to seeing your work.

Author Bio

Jason B. Kohl is an Austrian/American filmmaker from Lansing, Michigan. He completed his BA in English at Kalamazoo College before moving to Berlin, Germany, on a Fulbright Scholarship. He stayed on after the Fulbright, living and working in the German film industry for two more years, until he was accepted into the MFA Production/Directing Program at UCLA Film School in Los Angeles.

His UCLA MFA Thesis Film *The Slaughter* premiered at the 2013 SXSW Film Festival, was a Student Academy Award Finalist and played several other film festivals including Locarno and BFI London. *Filmmaker Magazine* called it "A masterfully directed story." The film was released online in 2014 through Short of the Week and was selected as a Vimeo Staff Pick. His documentary short *80 to 90 ft* premiered at the 2014 Los Angeles Film Festival and was acquired for television distribution by American Express.

After completing his MFA, Jason returned to Berlin on a DAAD Artist Scholarship. He remains based in Berlin, where he does commissioned work with his partner Nora Mandray. As "Mako," their clients include Etsy, MSNBC, and Vocativ. He is currently working on his first feature film, which, like all his other films, is set in Michigan.

Film School Budgeting Worksheet

SCHOOL NAME:

PROGRAM LENGTH:

EXPENSES

TUITION		HOUSING		CAR	
Year 1:	$0.00	Year 1:	$0.00	Year 1:	$0.00
Year 2:	$0.00	Year 2:	$0.00	Year 2:	$0.00
Year 3:	$0.00	Year 3:	$0.00	Year 3:	$0.00
Year 4:	$0.00	Year 4:	$0.00	Year 4:	$0.00
Subtotal:	$0.00	*Subtotal:*	$0.00	*Subtotal:*	$0.00

LIVING		STUDENT FILM COSTS		MISC (Travel, Equipment)	
Year 1:	$0.00	Year 1:	$0.00	Year 1:	$0.00
Year 2:	$0.00	Year 2:	$0.00	Year 2:	$0.00
Year 3:	$0.00	Year 3:	$0.00	Year 3:	$0.00
Year 4:	$0.00	Year 4:	$0.00	Year 4:	$0.00
Subtotal:	$0.00	*Subtotal:*	$0.00	*Subtotal:*	$0.00

INCOME

WORK/STUDY		GRANTS/ SCHOLARSHIPS		ADDITIONAL AID	
Year 1:	$0.00	Year 1:	$0.00	Year 1:	$0.00
Year 2:	$0.00	Year 2:	$0.00	Year 2:	$0.00
Year 3:	$0.00	Year 3:	$0.00	Year 3:	$0.00
Year 4:	$0.00	Year 4:	$0.00	Year 4:	$0.00
Subtotal:	$0.00	*Subtotal:*	$0.00	*Subtotal:*	$0.00

FINANCIAL AID

Year 1:	$0.00
Year 2:	$0.00
Year 3:	$0.00
Year 4:	$0.00
Subtotal:	$0.00

EXPENSE:	$0.00
INCOME:	$0.00
TOTAL COST:	$0.00

Applying to Film Festivals Worksheet

Name	Early Deadline	$ Entry Fee	€ Entry Fee	Submissions Open	Date Submitted	Yes/No	Oscar Qualifying	Premiere Requirement?	Informed by Selection By?	Festival Dates	Festival Website	Notes

A Reading List for Aspiring Filmmakers

OTHER WRITERS ON FILM SCHOOL (SEARCH FOR)

Film Crit Hulk: Should You Go To Film School?
John August: Is Film School Necessary?
John August: How to Get Into Film School?

ESSENTIAL ONLINE READING FOR FILMMAKERS

Deadline
Indiewire
Filmmaker Magazine
No Film School
Film Crit Hulk
Variety/ The Hollywood Reporter
Short of the Week
John August

READING AND VIEWING MATERIAL (SEARCH FOR)

AFI 100 Greatest Movies
Sight and Sound 50 Greatest Movies
WGA 101 Greatest Screenplays
The Criterion Collection
Short of the Week
Cinema 16
Vimeo Staff Picks
The 100 Best Documentaries on Netflix
The World Library's 100 Greatest Books of All Time
The Modern Library's 100 Greatest Works of Fiction
The Modern Library's 100 Greatest Works of Nonfiction

BOOKS FOR FILMMAKERS

Each of these books has been a personal help to me in my creative life.

The Creative Process

1. *Mastery*, by Robert Greene
 An excellent book that traces the process of achieving mastery in a field
 through the examination of the lives of several contemporary masters.

2. *The War of Art: Break Through the Blocks and Win Your Creative Battles*, by Steven Pressfield
 The best book for overcoming procrastination, fear and resistance to our creative paths in life.
3. *What I Talk About When I Talk About Running*, by Haruki Murakami
 This is ostensibly a book about running, but is just as much about the discipline and difficulty involved in choosing a creative life.

Managing Your Life

1. *Getting Things Done: The Art of Stress-Free Productivity*, by David Allen
 The classic guide to getting organized and accomplishing what you need to do.
2. *Your Money or Your Life: Nine Steps to Transforming Your Relationship with Money and Achieving Financial Independence*, by Vicki Robin and Joe Dominguez
 An essential book on financial planning and management.
3. *Nine Things Successful People Do Differently*, by Heidi Grant Halverston
 An excellent, very brief read on how successful people define and accomplish their goals.

The History of the Film Industry

See "Learn The History," pp. 63–64 for a detailed discussion of these books.

1. *The Big Screen: The Story of the Movies*, by David Thomson
2. *Easy Riders, Raging Bulls*, by Peter Biskind
3. *The Mailroom: Hollywood History from the Bottom Up*, by David Rensin
4. *Down and Dirty Pictures*, by Peter Biskind
5. *City of Nets: A Portrait of Hollywood in the 1940s*, by Otto Friedrich
6. *Sleepless in Hollywood: Tales from the New Abnormal in the Movie Business*, by Lynda Obst
7. *The Revolution Was Televised: The Cops, Crooks, Slingers and Slayers Who Changed TV Drama Forever*, by Alan Sepinwall

Screenwriting

1. *Poetics*, by Aristotle
 Perhaps the most influential book in the history of dramatic theory; Aristotle muses on what makes for great dramatic writing.

2. *The Elements of Style*, by E. B. White
 The ultimate guidebook to proper English composition.
3. *Screenwriting 101*, by Film Crit Hulk
 Most screenwriting books are full of fantasies about the perfect technique to create a million-dollar screenplay. This book is different: a practical, realistic discussion of storytelling strategies from one of the world's best contemporary writers on film and television.
4. *On Filmmaking*, by Alexander Mackendrick
 Legendary filmmaker and screenwriter Alexander Mackendrick (*The Sweet Smell of Success*) also had the benefit of a multi-decade teaching career. The result is one of the most sage, helpful books on storytelling ever.

Directing Actors

1. *A Sense of Direction*, by William Ball
 A beautiful, practical meditation on the role of the director. This book is based on the author's experience as a theater director, but much of what he says is directly applicable to directing actors in film.
2. *Notes on Directing*, by Frank Hauser
 Perhaps the most succinct, practical, intelligent, engaging book on being a director I've ever read. Also on theater, but almost entirely applicable to film.

Cinematography

1. *The Filmmaker's Eye*, by Gustavo Mercado
 A very good contemporary look at shot sizes and their use in visual storytelling.
2. *The Visual Story*, by Bruce Block

Editing

1. *In the Blink of an Eye*, by Walter Murch
 The definitive book on editing, from one of the world's master editors.
2. *When the Shooting Stops, the Cutting Begins*, by Ralph Rosenblum
 Ralph Rosenblum is perhaps most famous for editing Woody Allen's iconic *Annie Hall*. This book tells the process behind the making of that film and many others. You guessed it, they were made in the editing room.

Producing

1. *Shooting to Kill,* by Christine Vachon
 A smart, clever look at the life and work of the indie producer by one of the leading voices in the field.
2. *The Complete Film Production Handbook,* by Eve Light Honthaner
3. *Hope for Film: From the Frontline of the Independent Cinema Revolutions,* by Ted Hope

Networking/Professionalism/The Industry

1. *Letters to Young Filmmakers,* by Howard Suber
 A series of common questions asked by students about every imaginable subject related to the film industry, answered by a member of UCLA's faculty who's taught for over 50 years.
2. *Good in a Room,* by Stephanie Palmer
 An excellent little primer on meetings, pitches, developing your network and more.

Living a Good Life (Creating Values and Being Happy)

1. *How Will You Measure Your Life?* by Clayton M. Christensen
 A simple book about the choices we make in life and what they mean.
2. *A Guide to the Good Life: The Ancient Art of Stoic Joy,* by William B. Irvine
 An excellent introduction to Stoic principles, which can be a great arsenal against the chaos and joy of a creative life.
3. *Letters to a Young Poet,* by Rainer Maria Rilke
 The advice of a famous poet to an emerging one; beautiful little letters on creativity and perseverance.
4. *Self-Reliance,* by Ralph Waldo Emerson
 Some thoughts on defining your own values and destiny by the first and foremost American philosopher.
5. *The Tao of Pooh,* by Benjamin Hoff. A great philosophy explained by a great philosopher.

Index